S0-BZO-007

At 75 Lou Stoumen's life experience has been an odyssey of high adventure. As writer, photographer, soldier, filmmaker and professor he has wandered all the world's continents by motorcar, ship, air, on foot, dogsled (Alaska) and by train across all of India. He flew from China in the first B-29 raid against Japan. During these travels of more than half a century he got to know both the famous and unknown personages whose brief biographies and photographs comprise this book. Winston Churchill is here, and Marlene Dietrich, Carl Sandburg, Paul Robeson, Frank Sinatra, Pauline Kael, Ansel Adams and Aldous and Laura Huxley. Also, a Times Square prostitute, an American steelworker's daughter, a Calcutta beggar child, the giant Buddha of Kamakura, Japan, a tree that refused to die, and a true inside account of why the Vietnam war need never have happened.

Stoumen was born in Springtown, Pennsylvania, son of a country doctor and a piano teacher mother. Graduate Lehigh University. Film studies University of Southern California. Author ten books and portfolios of text and photographs. Writer-director-producer of many films of which five won Academy Award nominations and two Oscars. He is now professor emeritus from UCLA Film School. His books, photographs and films are available in permanent collections of Museum of Photographic Arts San Diego, Museum of Modern Art New York, Center for Creative Photography Tucson, International Center of Photography New York, George Eastman House Rochester, Museum of Fine Arts Houston,

Continued on back flap

ABLAZE WITH LIGHT AND LIFE

A Few Personal Histories

FRIEND, WHY WOULD YOU WANT
TO SHORTEN MY LIFE BY TAKING
AWAY MY SHADOW?

> *Crazy Horse*
> *Chief of the Oglala Sioux*

WHYNCHA MIND YOUR OWN
BUSINESS? WHYNCHA TAKE
THAT CAMERA AND SHOVE IT!

> *On the street, New York City*

GOD DWELLS IN DISGUISE IN
THE FACES OF THE POOR, THE
FORGOTTEN, THE SICK AND THE
LONELY.

> *Mother Teresa of Calcutta*

A BOOK MUST BE AN ICE-AXE TO
BREAK THE FROZEN SEAS INSIDE
OUR SOULS.

> *Franz Kafka*

WHAT IS TO GIVE LIGHT MUST
ENDURE BURNING.

> *Viktor Frankl*

Sonoko Kondo

NOW that I've come well past 70, writing and photographing all the way, a curious magic seems to happen. Places I wrote about and photographed—across five continents and more than half a century—are now becoming something else. My journal notes and photographs grow a patina of history.

What happens to the photographs of faces is especially strange. The old images talk back. *You weren't really looking when you photographed me,* they say. *What right did you have to steal my picture?*

An accretion of meaning foams on the river of time. The young woman photographed in 1937, if she still lives, now wears a less firm skin, dyed or graying hair, and a different grandmotherly beauty. Some others long ago photographed—the famous, strangers in the street, friends—no longer reflect light at all. They've become dust. That childhood picture of myself, that wide-eyed kid, he's become ancestor of the face in this morning's mirror. *Who is that old man in my body?*

There's been no actual change in the photographs or in my journal notes. They are both jelled memory, paper fossils. What changes is you and me, what we come to be and know. The supposed wisdom of elderly people may simply be their increase in experience—more memory tapes, plus the grace of longevity.

I chose the light-struck faces in this book from many thousands photographed. Obscure or known, most of these faces (not all) seem able to shine through without

deploying a social mask. They seem open now to dialogue, as some were not when we met, a camera between us. They seem now to come alive with the words and light and smells of place. A personal history of our times since the 1930s emerges. My own life and face also, because some autobiography has become unavoidable in making this a true book.

What these memory movies bring to me now, and I'd hope to you, is a subtle gift: intimation of our own divinity. For if anything like God exists—and I'm open to that possibility—such power must surely manifest not in icon or theology but in works. A tree. A cloud. A fish. A cell, programmed. A bush of blueberries. A million suns of which one warms us. The products of work. The process of love. A human face.

The taking of photographs requires a certain force. Primitive peoples are not wrong in fearing the camera as a stealer of souls. Something is taken away during *exposure* —a moment, an aspect, a sometimes cruelly distorted selfness to be optically eaten by others.

I think of some of my street photography as camera rape. My confabulation of words might also sometimes be invasive of persons. My defense has always been that the end—the photograph, the tale told—justifies the means. Yet this is a queasy principle I reject in other circumstances.

When I do take such photographs, write such writing, I presume to compare myself to an Indian hunter whose arrow takes living game with necessity and reverence.

My arrows are seeing and voicing. I stop time. I flash messages of form, meaning and sensibility across the years. I think such work is useful. For what can happen with a well-taken photograph of a face, or a perceptive revealment in words, is that we see into them as into a mirror. We read there our common mortality. We are shocked to recognize in the eyes and heart of a stranger our own consciousness.

This is sweet, like an act of love. For it assures us once more we are not alone, that the universe is a connectedness ablaze with light and life. ▲

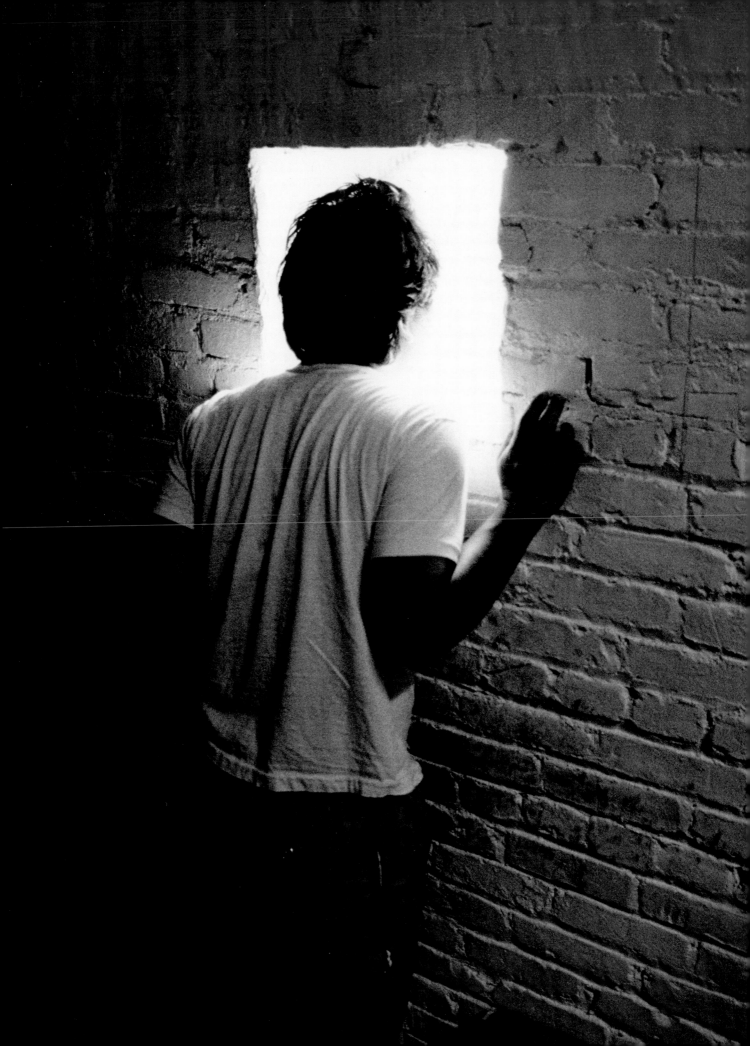

ABLAZE WITH LIGHT AND LIFE

A Few Personal Histories

LOU STOUMEN

Celestial Arts Publishing
Berkeley, California

For my daughters, with love

Mary Lee Baranger
Toby S. Caraza
Tatiana Stoumen

Composition and text design by Lou Stoumen and Reneé Robinson.
Cover design by Marcus Badgley, Gravity Design.

FIRST PRINTING 1992

Library of Congress Cataloging-in-Publication Data

Stoumen, Louis Clyde.
 Ablaze with light and life : a few personal histories / Lou Stoumen.
 p. cm.
 Includes index.
 ISBN 0-89087-671-1 — ISBN 0-89087-670-3 (pbk.)
 1. Photography, Documentary. 2. Stoumen, Louis Clyde. I. Title.
 TR820.5.S8 1992 91-37442
 779'.2'092—dc20 CIP

1 2 3 4 5 6 7 8 9 10 / 96 95 94 93 92

Fronticepiece
Los Angeles sculptor Sakai looks out new
window he's broken through brick wall
of his studio.

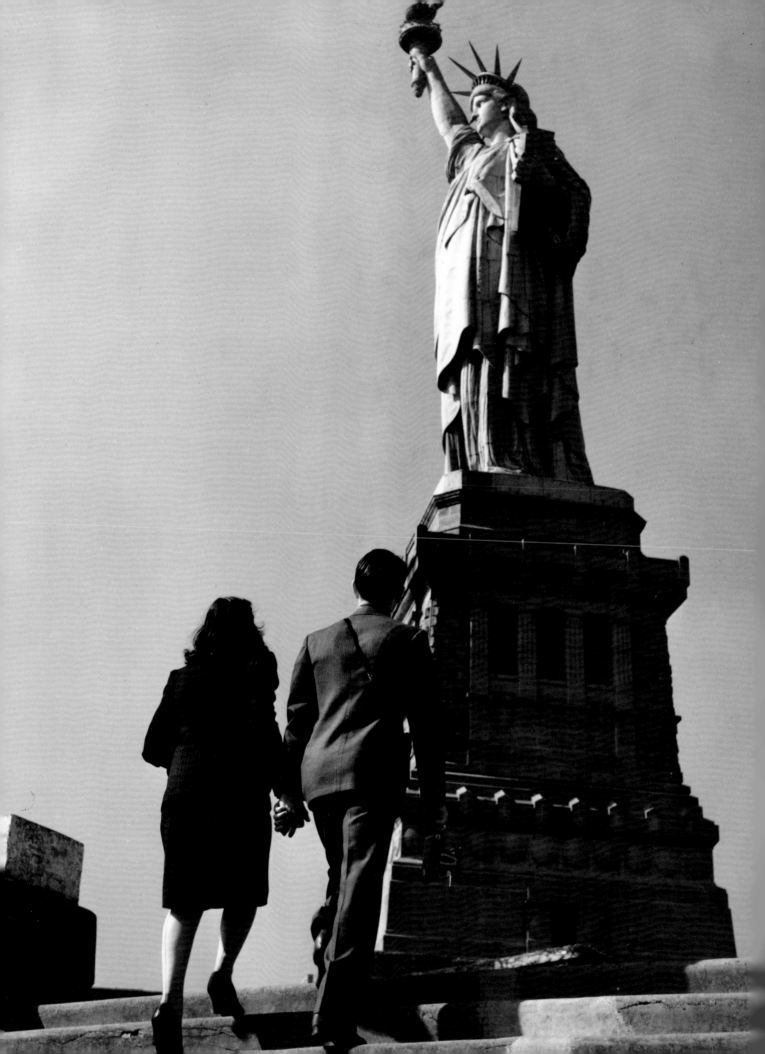

ALL WE HAVE TO FEAR
IS FEAR ITSELF . . .

Franklin Delano Roosevelt

one

BACK THEN

THE STATUE OF LIBERTY

THOSE DAYS

We children of the 1930s, at least in Bethlehem, Pennsylvania, had it pretty good. Perhaps because we didn't know better. Many of our parents were unemployed those hard Depression years. Many families, including mine, lost their homes to the bank. The stock market crashed, kaboom! Most of the banks went broke, mysteriously disappearing the life savings of millions of fathers and mothers. Bethlehem Steel Company laid off thousands of workers. Parents cried in front of their children. There were suicides.

Federal bank deposit insurance didn't exist. There was no unemployment insurance, or health plan, or antibiotic drugs. If somebody, including kids, got pneumonia or diphtheria or tuberculosis, they likely died.

But those days families stayed together, which gave everybody confidence. Divorce was uncommon and shameful. Neighbors, relatives and strangers helped each other with food, child care, house repairs, small loans of money, and hugs.

Most high school girls and boys were virgins. Sexual diseases were rare, none quickly fatal. Race and religion, in Bethlehem, seemed then to be no big deal; Jews, Blacks, Mexicans, catholics, protestants and recent immigrants from Europe didn't much socialize or intermarry, but they got along, and their kids were schoolmates and friends. Violence in the streets was seldom worse than Saturday night fist fights. The only commonly used drugs were alcohol and tobacco, and we learned from the movies that drunks were funny and smoking proved you were grown up.

There were no jet planes then, or serious plastics, or pantyhose, no TVs, computers or shopping malls. Radio was everything, and the Movies—and Life magazine, Eddie Cantor, cowboys, Buck Rogers and baseball cards. Girl Scout cookies were actually baked by Girl Scouts (plus their mothers). Also happening were jazz, blues, square dancing, Benny Goodman, Caruso recordings, Louis Armstrong and Bessie Smith.

Looking back now, maybe the best thing we had going was good schools. Our teachers were bright, mostly older spinster ladies, with a few men as principals and coaches. They all seemed interested in teaching us love of learning. There was lots of homework.

I remember Mr. Barthold, principal of Donegan Junior High, who told us freedom of speech was *our birthright*. He brandished over his head a copy of The New York Times and explained why it was *the world's greatest newspaper*. And at Liberty High School Miss Nellie Bustin and the sisters Crow (Emma and Mary) lovingly taught us the beauty and usefulness of the English language, and how to write it. *Mammy* Hess taught German and

Latin (yes) in her own severe, European way, which many of us resented—but we *learned* those languages. And Mr. Dando, who taught History and Civics, planted in our minds the ridiculous idea that tobacco was bad for our health. He called cigarettes *coffin nails*.

Everybody had huge respect for school teachers, whether we entirely agreed with them or not. To be a teacher those days was like being a doctor or a minister, sort of a local movie star. ▲

ONE SIZE FITS ALL

During the 1930s Joe Bannon's Pool Hall did business in the cellar of a furniture store on the workingclass south side of Bethlehem, Pennsylvania. JB's was a much appreciated refuge for sports fans, gamblers, unemployed steelworkers, city policemen, unhappy husbands, class-cutting undergrads from Lehigh University, and an occasional ne'er-do-well Liberty High School boy like myself. No female person ever ventured down to this smokey windowless bastion of male ritual.

Besides its two pool tables, JB's offered a serve-yourself ice chest of bottled root beer, Moxi, Coke and Pepsi (each five cents). Also, behind the cash register were draw-string bags of Bull Durham Tobacco (with rolling papers), readymade packs of Lucky Strikes, Chesterfields and Melachrinos, and items like candy bars, chewing gum, pencils, breath mints, Trojan and Shiek condoms and hard-rubber combs. The radio was always turned to The Ball Game.

There was also a back room with a closed door. When intent men went in and out I glimpsed a ticker-tape machine under a glass bell clicking out an endless paper strip of—what? Stock market quotes? Game scores? Once I started to walk in and Joe Bannon spoke up in his clear Irish tenor: *Hey, Louis! You stay outta there. You gotta be twenty-one.*

I learned to be a fair pool player at JB's, though I lost more bets than I won, which meant I had to pay for the games too. But I never did figure out what went on in that back room. I think now it was a branch of a numbers racket headquartered in New York or Philadelphia. Joe sure didn't make his living those Depression years from Moxi and two usually dark pool tables.

Joe was a good man, with a sense of justice. More than once I heard him arbitrate angry men down to peacefulness. He also had a sense of humor. Once, in expectation I was about to lose my virginity (didn't, it turned out), I whispered to Joe I'd like to buy a pack of—Trojans. He didn't smile. *Small, medium or large?* he said, in a louder than usual voice.

I thought fast. If I ordered *Small,* it wouldn't sound manly. If I said *Large,* I'd be boasting. *Medium,* I squeaked. ▲

14

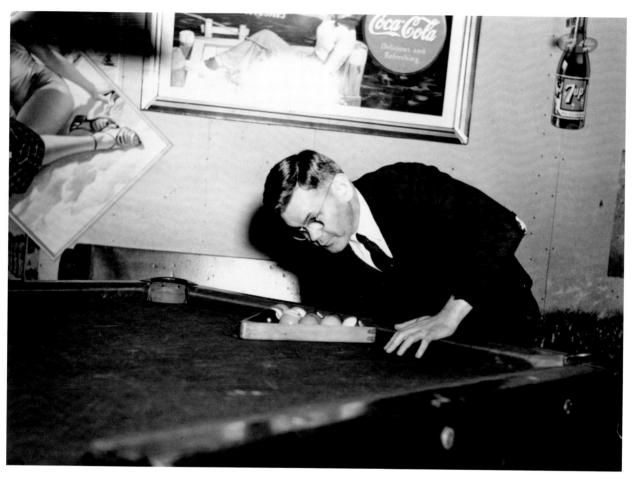

JOE BANNON SETS UP A RACK OF BALLS.

THE BOATHOUSE

Back in the 1930s the appearance of a camera was an exciting opportunity for children. Cameras were expensive. Not every home had one. These kids posed eagerly, crowding against the porch railing of their home, which was a block-long, 19th century wooden shack alongside a coal yard and the railroad tracks. It was also near the Lehigh River, a tributary of the Delaware. Before the Lehigh nearly silted up with industrial waste, the area was a resort and the long structure housed rowboats and canoes. Now, in the 1930s, it was still known as The Boathouse. The brick monolith in background was national headquarters of Bethlehem Steel Company.

Why do you make pictures here? the oldest child wanted to know. *Do you work for the*

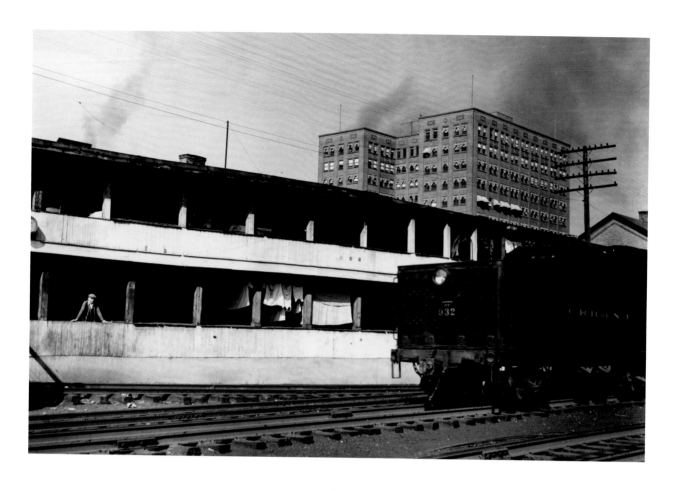

steel company? I work for myself, I said. *Maybe the pictures will be in a magazine, or a book.*

Reassured, Mercedes Gonzales told me her name, her age (11), and what she knew about her family's history. Seems a work gang of Mexicans, including Mercedes' father, was imported in freight cars by Bethlehem Steel Company to break the great 1919 strike. Now, almost two decades later, 29 families of those workers, many unemployed, lived in The Boathouse. *We have rats and broken pipes,*

Mercedes said. *It's a shame you can't make pictures of the smell.* ▲

The Bethlehem plant of Bethlehem Steel Company is now dead. Cranes and blast furnaces rust in the empty yards. After World War II Germany and Japan rebuilt their destroyed furnaces and mills with more efficient technologies. Shortsighted Bethlehem Steel management didn't, its eyes on quarterly profits rather than research, investment and their working people. By the 1980s they could no longer compete.

BIKERS

I never aspired to join Hells Angels because when I started to ride in 1934 that organization hadn't happened yet. And by the '60s, which was the Angels' heavy decade, I'd already earned a skull fracture totaling my fathers Oldsmobile and had learned serious lessons about fear, thrills and death during World War Two. An accretion of such experience inclines one to stodginess and caution.

Anyway, I was 17 when I bought my beatup old Harley-Davidson. Big noisy mother. Cost all of twenty-two dollars, which was money those days. I cleaned it, greased it and sort of learned to ride, all in one weekend. ZOOM! ZOOM! Faster than any horse. Sweeter than any automobile. Friend of the wind. Down close to the speed-blurred road. All that power and roar responsive to the touch of my right hand on the handlebar. *You and the machine are one. VAROOM!*

Great thing was, most young girls (when out of sight of their parents) couldn't say no to an invitation to ride. They'd sit curled softly against your back, thighs pressing yours, arms around your waist, and they'd yell and laugh and scream and *hold on.* It's a very male-female experience, a bit beyond friendship, out of which could soon grow a sexual experience . . . you hoped.

About a month after acquiring my bike I rode to the Freemansburg Motorcycle Races and Hill Climb. This was a famous annual event that every Spring drew hundreds of bikers from many states to the little town of Freemansburg in eastern Pennsylvania. I didn't dare compete in any of the dirt-track races, certainly not in The Hill Climb, which was a grueling test of courage and skill up a 35 degree mountainside of dirt and loose rocks. More often than not riders were unseated. Bikes upended over their heads. Injuries were frequent.

I did make photographs, and some friends, and was an excited and appreciative spectator. Those calm experienced riders made it all look so easy. Riding home, after a brief Spring rain, I rode with new confidence and abandon.

East Fourth Street, about a mile from my home, was an uphill thoroughfare with shiny trolley tracks down its center. As I reached it, three old automobiles were puttering uphill at maybe twenty-five miles an hour. Pooh on that! I swung out to pass, roared uphill between the trolley tracks, passed the cars as oncoming traffic approached, and swung back in toward my proper right-hand lane.

Oops! The trolley tracks were still wet from the recent shower. My rear wheel spun out on the slick tracks and suddenly I was bike-free and airborne, catapulting up and up and then down somehow to a one-point landing on the right cheek of my ass. I landed in the cement gutter of the curb, two feet behind a parked car.

Didn't feel pain yet, just a heavy

consciousness into which penetrated the immense sound of *ROAR!!* It was my poor motorcycle lying there athwart the trolley tracks, complaining the loudest it ever could. Apparently as I flew off I'd twisted its handlebar throttle to the max. Now my little beast was voicing its displeasure to the entire neighborhood. People were running outdoors and crowding windows. I wasn't scared, or yet in pain. I was embarrassed. I rolled over, crawled to my fallen bike, and managed to switch off its ignition. A sudden blessed silence.

Good neighbors carried me indoors to a couch and gave me coffee. Somehow no bones or even skin had been broken. But I had the biggest bruise you can imagine, my entire right buttock an angry mottled red (which over succeeding weeks rainbowed to blue and purple and yellow and sickly green and hurt like hell).

After about an hour, with a cold wet towel on my bottom, I found I could stand and walk. I thanked my rescuers, mounted the bike, which had not been damaged, and somehow rode home side-saddle.

Get rid of it! my father said. I did. ▲

CARL SANDBURG

The greatest living American poet descended from his railroad car like God from a cloud (so it seemed to me) and shook my hand. As chair of the university student lecture committee it was my duty to meet his train and take him to his room at Hotel Bethlehem.

Carl Sandburg turned out to be a friendly modest man—down home, plain spoken, curious about everything. He was slight of build, quick of eye (blue eyes, as I remember), and childlike in a bright adult way. His luggage consisted of a small suitcase, a guitar case, and a small, worn, leather-covered manuscript box.

He ordered tea, fruit and sandwiches from room service and invited me to join him. He wanted to know all about Lehigh University, Bethlehem—and myself. And since his lecture was not till tomorrow evening, would I be kind enough to show him around town in the morning? And would I (I'd confessed) bring along some of my own poems?!

Bethlehem, Pennsylvania was founded Christmas Eve 1740 by a small band of religious refugees fleeing war and persecution in central Europe. They were known as Moravians, or United Brethren, and in their theology and pacifism were much like the Quakers. They broke ground on wooded Indian wilderness along the north bank of a river in what was later named Pennsylvania, and built homes, a church, a school, workshops and the first city waterworks in North America. Sandburg,

historian as well as poet, was fascinated.

We walked through the huge beautiful church (1801), the sprawling stone Widow's House (1745) where elderly Moravian women still lived, and the four-storey stone Seminary and College For Women (1748), which was used as a hospital for wounded troops of General Washington fighting the British at Valley Forge.

Lafayette slept in Bethlehem, and Ben Franklin. The Liberty Bell was trucked by horse from Philadelphia through Bethlehem's Main Street on its way to Allentown and safety from capture by British troops. Sandburg was delighted (he slapped his knee!) to read a passage from an early Moravian archivist's journal: *We have all occupations here including schoolmasters, farmers, preachers, tradesmen, an artist, an accountant, carpenters, an engineer, a surgeon, weavers— except soldiers, and lawyers, for whom we have no need . . .*

The miles-long spread of grimy Bethlehem Steel Company structures along the river opposite historic Bethlehem produced a different mood in the poet. He regarded its array of thunder-sounding blast furnaces and its phalanx of smoke-belching stacks with somber attention. At the Coke Works, where little iron cars dumped still-glowing coke lava down the side of a man-made mountain, we met some children of Mexican steel workers. Sandburg perked up at once. He smiled, laughed with them, told little stories, and hugged them for my camera.

We had lunch and conversation at a mom-and-pop restaurant in nearby Hellertown. Over coffee, Sandburg opened his manuscript case and handed me a sheaf of unbound printer's galleys from the forthcoming fifth volume of his six- volume biography of Abraham Lincoln, on which he'd been working for thirty years (it eventually earned two Pulitzer prizes). Would I like to read proof on them, he asked—while he looked at pages from *my* first book (just then going to press) . . . I was pleased to find and correct several errors of typesetting in the galleys of Sandburg's magisterial prose. He told me he liked my work—and wanted to think more about it.

That evening, to a full auditorium of students, faculty and townspeople, Sandburg sang old folksongs (to his own guitar), read mostly Chicago poems (including the one about *fog coming in on little cat feet*) and spoke directly about large matters like love, art, Lincoln and the probability of war in Europe.

I remember few details of Sandburg's presentation because early on he congratulated the audience that they had in their midst a new poet of their own—*me,* and should look forward to publication soon of my first book. He said my use of photographs in counterpoint to the poems was *a new form worthy of a wide American audience* . . . I dissolved immediately into a floor puddle of light-headedness, embarrassment and drunken pride.

Sandburg was wrong about my poems. Over the years I've turned out not to be a poet at all. What I do is write prose and make photographs, sometimes films. But that book (*First Poems and Camerawork,* 1939) was over-wrought juvenilia.

More than fifty years later, now, I think I've gotten a handle on what was in the master's mind when he laid on me such public kudos. Checking out reference books preparatory to writing this piece, I learned that way back in 1904, when Carl Sandburg was a student at Lombard College in Galesberg, Illinois, his English professor helped him self-publish his first book of poems, *In Reckless Ecstasy.*

In later years Sandburg must have winced at recollection of that title—and quite likely its poems. I suspect college-boy Sandburg's *In Reckless Ecstasy* had to be almost as unreadable, and teenage horny, as my own first book. I think elder Sandburg just saw in this eager Pennsylvania kid something of his own early self and decided here was a seed that might grow.

I'll always be grateful to Carl Sandburg for confirming that day what as a boy I was beginning to suspect—that I had a calling.

Years later my teaching at UCLA must

have been informed by this experience. Turns out it's worth giving generous strokes to promising but less than excellent students. What often results is at least productivity, sometimes innovation and excellence. ▲

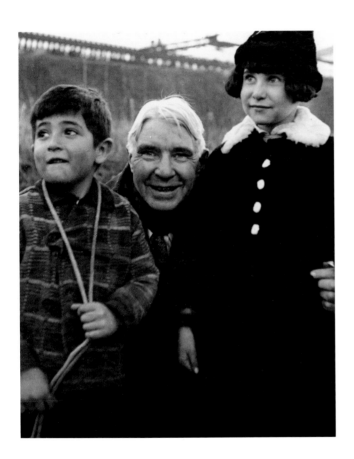

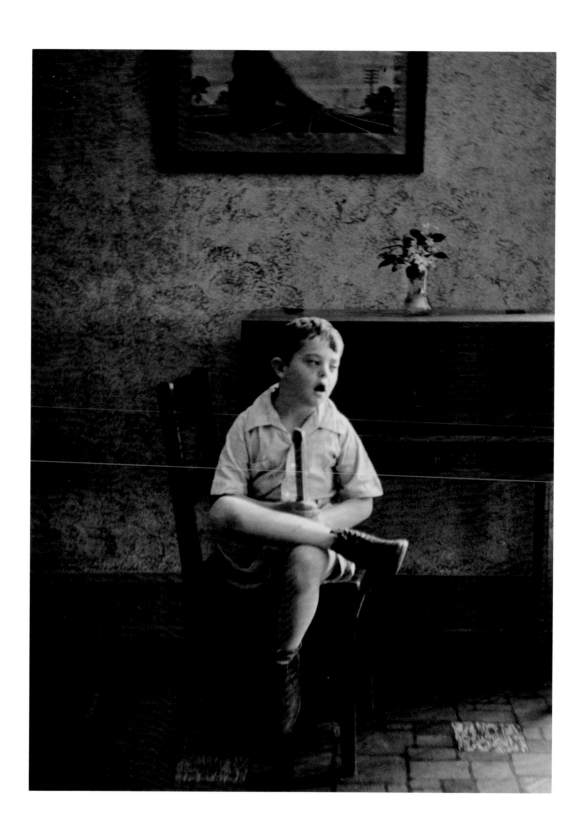

ZERO

*M*ongolism, the doctor-professor called it for our visiting psychology class. *The skull is flat and broad. The eyes are slanted. Musculature is flabby, babylike. Intelligence ranges from idiocy to imbecility, which isn't far. The condition is congenital and prognosis for significant improvement is zero.*

The good hospital nurses had dressed the boy for our visit in clean pressed clothes, nicely tied high shoes. They displayed him in the family visiting room—with the vase of flowers, the picture of the locomotive. The gentle boy with his empty slanted eyes, his open wordless mouth. Zero.

I stole this photograph by shooting from under my books.

Afterwards we were sobered students, all of us glad for fresh air beyond the locked doors.

 * * *

Today, doctors, and many parents, are more accepting of such children. The condition is now referred to as Down's Syndrome. It affects about one in 800 live American births.

The brains of such children do have limited capacity for learning. But if they are raised with respect and love many do learn, and live happily into their 50s and 60s. Some become employable and enjoy the pride of work, earnings, even marriage. Such children, and adults, seem naturally warm-hearted and affectionate. They're not smart enough to kill, cheat or lie. ▲

ENDS AND MEANS

John F. Kennedy was assassinated in Dallas, Texas, on November 22, 1963. The world grieved over the loss of America's young president. Hardly anyone noticed amid the mourning that one of the great philosophers, writers and teachers of our century also died that day, at 69, under remarkable circumstances.

Aldous Huxley was born into the Eton-Oxford-Cambridge intellectual aristocracy of late 19th century imperial England. His grandfather, a sea-going surgeon in the royal navy, published his first research paper (on South Pacific marine life) at age 20, campaigned in defense of his colleague Charles Darwin's *intelligible hypothesis on which to base a study of evolution.* His father was a schoolmaster. His brother Andrew won a 1963 Nobel prize for discoveries about the electrical conduction of nerves.

Aldous Huxley himself, despite an eye infection at 17 that left him permanently wall-eyed and half-blind, published more than 50 books. He reinvented the English novel (*Chrome Yellow, Point Counterpoint*). He was a genius polymath, professionally interested in *everything*—poetry, fiction, philosophy, art, sex, religion, psychology, history, all the sciences and, especially, the uses and corruptions of language. His ideas were ahead of his time, prophetic.

In his 1937 book *Ends and Means* he predicted a dramatically increasing birth rate in the Third World (with Britain unable to sustain its empire); chaos in family life due to increasing use of birth control in indus-trialized nations; television, once perfected, as an agency of propaganda and corruption of values; and a soon-to-be great war in which civilians would be exposed to risks as great as those faced by fighting men.

It was this paragon of world culture who in the autumn of 1938 came to lecture on the conservative campus of Lehigh University. It was my privilege to meet his train. He was tall (six feet four inches), soft-spoken (broad English accent), wore a broad-brimmed hat and a heavy tweed coat. At the hotel he bowed his head five inches close to the brass numerals on the door of his room, squinted, then asked me: *Is this five-naught-six?* It was.

Next evening, before his lecture, Huxley dined with mostly engineering students at their fraternity house on campus. The students were cordial and respectful. The food was good. But few of the students had read any of his books or were equipped to discuss his ideas. Some tried to talk sports.

In the auditorium Huxley, in black tie and tux, spoke with gentle passion about war and peace, and about ends and means. He said that *the way we do things determines the results. Means determines ends.* We use language so badly that we become believers of our cliches.

Huxley offered his audience of students, faculty and Bethlehem townspeople two remedies. First, he urged close study

about how we use words. *Analysis of language,* he said, *is universally subversive. If words were used as they ought to be used, there would be an end of advertising, political oratory, ideological fanaticism of every kind. The doctrines of Nazism, Communism, nationalism, etc. are manifestly idiotic, but those who believe in them get an enormous amount of heart-warming excitement from their beliefs. This immediate excitement makes them forget the long-range disasters which such beliefs inevitably lead to.*

As for the imminent threat of world war, Huxley's remedy was absolute pacifism, non-resistance. No build-up of weapons in the name of defense. *Violence,* he said, *breeds violence. The means determines the end.*

Huxley was listened to respectfully. He drew polite applause. But he could as well have been lecturing to the moon. It was all very well for his elite audience to accept his characterization of Nazism and Communism as *idiotic.* But *nationalism* too? Did he really mean patriotism, love of country and the American flag were idiotic? And as for pacifism, didn't the greatest nation in the world have the responsibility to protect itself?

29

Besides, hey, Lehigh had one of the best ROTC (Reserve Officers Training Corps) programs in the country. All Lehigh undergraduates were required to take at least a year of dressing up, marching, saluting, shooting rifles at targets and listening to military and patriotic lectures. If they stayed with it for the full four years they graduated not only with their Lehigh degrees but with commissions as Second Lieutenants in the U.S. Army. So where does this funny-talking English wierdo come off telling us what's real?

There were on campus a few of us pleased by much of what Huxley said. His visit brought us a breath of fresh air on a campus awash with sports, fraternity hazing, alcohol, racism, sexism, and anti-intellectualism. Some of us even claimed conscientious objection to military training, and the University suffered us, provided we enrolled instead in a full year of Moral and Religious Philosophy. This was taught by the campus chaplain, Claude Beardsley, who did allow free discussion but whose beliefs were militaristic. *My own brother died in the First World War*, he told us. *I cannot accept the idea that he died in vain.*

We few campus radicals, however, couldn't accept Huxley's total pacifism. Did he really mean that the artists and writers and Jews and priests and workers of Nazi Germany shouldn't physically resist, even to save their lives? Did he mean that the people of Spain, already under attack by Nazi and Italian troops and bombers, should lay down their arms and accept the fascist yoke of General Franco?

Aldous Huxley impressed many that night with the eloquence of his presentation. He convinced practically nobody.

*　　*　　*

Huxley's last years were spent in Los Angeles, still averaging an intellectually challenging new book each year, and also, for money, writing or script-doctoring an occasional undistinguished screenplay for the Hollywood studios. He was bereaved of his beloved wife Maria, who had died of cancer, and married again, to Laura Archera, a pert, bright, attractive Italian woman who was a concert violinist and herself a writer. They had a pleasant country-like house in the Hollywood hills.

Living then in Los Angeles myself, I renewed our acquaintance. Soon thereafter came news that Aldous' and Laura's fine house had burned to the ground in one of Los Angeles' periodic Spring brush fires. Aldous and Laura watched the destruction of his entire library, all his letters, diaries, manuscripts and a writer's lifetime of memorabilia . . . Huxley passed this involuntary test of Buddhist non-attachment. The day after the fire he wrote: *It is odd to be starting from scratch at my age. I am evidently intended to learn, a little in advance of the final denudation, that you can't take it with you.*

Huxley's last major researches and writ-

ings were in the areas of mysticism and the therapeutic and spiritual uses of psychotropic drugs, specifically psylocibin, peyote, mescalin and LSD. His 1954 book *The Doors of Perception* was a best seller and, as usual, in advance of its time. To Huxley's surprise (and regret), it became the how-and-why-to-get-high manual for the 1960s. Huxley became, despite himself, along with Allan Ginsberg and Tim Leary, a *new age* guru.

Cancer of the tongue and throat. As Aldous Huxley lay dying in their new house near the big Hollywood sign on the hill, he asked Laura to give him LSD. She did.

In his last moments Laura whispered directly into Aldous' ear, asking at one point if he could still hear her. He squeezed her hand. *It is easy*, Laura said, reading to him from the Tibetan Book of the Dead, *you are doing this beautifully and consciously . . . forward and up toward the light, into the light, into complete love . . .* ▲

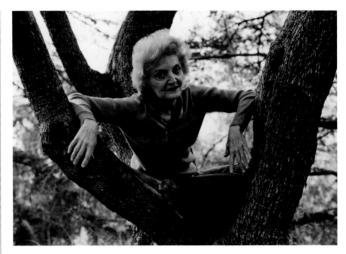

LAURA HUXLEY IN FIG TREE Hollywood

FAMILY MAN

He was a tramp actor in 1938, traveling the eastern United States in an old Essex. With him was a fat singer named Burl Ives, a guitar-picking songwriter name of Woody Guthrie, and a pretty girl, Herta Ware, whom he soon married. On the road they raised money from one-night stands at union halls and churches for defense of the Spanish Republic.

Will Geer and his players did scenes from Shakespeare and Clifford Odets, and original skits that made people laugh and cry. He was well over six feet, deep-voiced and Lincolnesque. He never said a word—over a beer or from the stage—that didn't snap like a whip, or go soft like butter, or sweetly stroke your face, whatever he wanted it to do.

During the 1950s and early 60s Will was on the un-American Committee's black list for being a radical, which he was, and he didn't work much, for money. Before those years and after he did just fine, enough to buy a spread in Topanga Canyon, Los Angeles, and build there a non-profit open-air theater and school. He greened it with all the plants mentioned in Shakespeare's plays.

I made this photograph in 1940, backstage at a Times Square theater between acts of Tobacco Road. That's Will on left, made up for the role of dirt farmer Jeeter Lester. The dude in the top hat isn't a banker come to foreclose. He's probably one of the producers, or an investor in the play.

Will liked all kinds of people. He always arranged to be with strangers, friends, his wife, students, children, grandchildren. You might say he was a family man.

The night he died at 76, in 1978, his bed in a Santa Monica hospital was surrounded by such family. They said goodbye by pleasuring the old man with a final reading of Shakespeare. As he made his last exit they were corny enough to sing, *So long, it's been good to know ya . . .*

This photograph is of *young* Will in 1940. He's costumed and made up to look much like Old Will would in 1978 playing TV's Grandpa Walton. That role, in *The Waltons* series, finally gave the whole American people a chance to join Will Geer's family. ▲

FISHER GIRL

I remember. I remember this girl, this near woman, as she watched me photograph the old racing schooner in the harbor of Halifax, Nova Scotia. It was the summer of 1939. Before the war. Before all the changes.

Would you take a picture of my fish? she asked, holding them up. Her voice was lilting, country, innocent. Her question, the calm openness of her manner, captured my heart.

I made two negatives, and we thanked each other. She did not ask to be sent a print. I did not think to offer one. Nor did I learn her name. Errand completed, she was gone home with her fish.

That night before sleep the thought occurred to me: was it possible this youngster was innocent of personal vanity? Was she only trying to be friendly? Could it be the meaningful matter to her was that the foreign visitor immortalize her *fish?*

* * *

Later, at the time of the war in Korea, I stood in snow near another shore, in Alaska, shooting motion picture footage of a native fishing village. Local children watched.

When we were finished and packing our gear, a young Indian girl (or Eskimo?) approached. She did not ask to be photographed. *Could I ask you a question?* she wanted to know. Despite the cold, she wore only a simple cotton dress, no stockings, low shoes. She reminded me instantly of my smiling fisher girl in Nova Scotia.

What's on your mind? I said.

Well, she said, *well—,* and then in a rush it came out: *Don't-you-think-it's-terrible-the-way-the-army-made-Elvis-cut-his-hair?* ▲

34

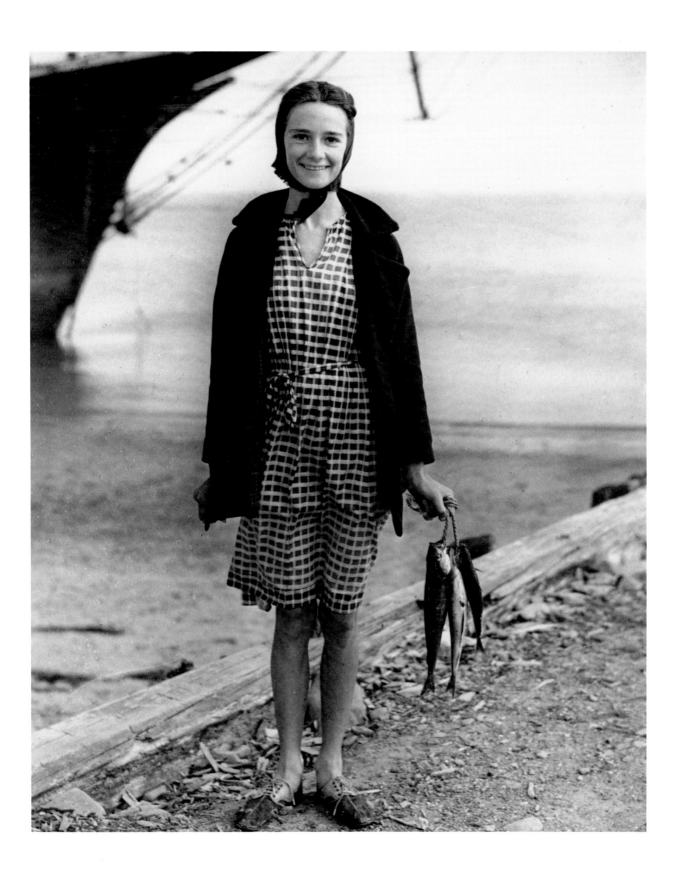

ROCKY

It's remarkable how a face changes, especially the one we check out daily in the mirror. A photograph is a mirror with memory. This face belonged 50 years ago to Nelson Rockefeller. He was then President Roosevelt's Coordinator for Inter-American Affairs. My camera caught him at San Juan airport on his way to an oil conference in Venezuela. Now Nelson Rockefeller is unwillingly retired from politics—and from life. He'd been three times governor of New York. Perennial candidate for the United States presidency. Rockefeller's grandfather John D., who founded the oil fortune back when there was no income tax, lived to be 98, passed on good genes and Standard Oil. More than one billion dollars. Money. You and I can't know what that is. Rocky knew. See it in the sureness of his glance, the easy fit of his dentistry, clothes, hair, errand.

Rockefeller! A name to open doors, make women weak. He had energy, boisterous good humor, and a dyslexia that made it hard for him to read speeches. He came to be head of the liberal wing of the Republican party, spoke for civil rights and the dignity of the individual. A haberdasher reached the presidency. Soldiers did it. A Texas politician. A Michigan football player. A peanut farmer-engineer. A young new-money Kennedy. So why not Rocky? It was his life's ambition.

Maybe he'd made mistakes. He'd been a cold warrior and a Vietnam hawk who campaigned for every family to have a backyard bomb shelter (as if every family could even afford a house). Forty-three prisoners died at Attica State Prison and many blamed the governor. A hurried divorce may have cost him the '64 presidential nomination.

There were consolations. His love and sharing of art. The vice presidency for a few months under Gerald Ford. His sons, daughters, grandchildren and brothers. A new young wife named Happy when he was 55. Like the Pharaohs, the Rockefeller dynasty left monuments. Rockefeller Center. The Rockefeller Foundation. The University of Chicago. While still living, Rocky gave away more than 33 million dollars, including establishment of the Museum of Primitive Art and kingly gifts to the Museum of Modern Art and the Metropolitan Museum.

It's remarkable how faces change. When he died at 70 in 1979 Rocky had pouches around his eyes and his young man's jaw line was puffed with jowls and perhaps disappointment. He died of a heart attack on a couch in his 54th Street Manhattan townhouse about 11:15 PM, alone there with blond 25–year-old Megan Marshack. According to a Rockefeller family spokesman Marshack was a research assistant working on a series of art books. According to columnist Jimmy Breslin, when the paramedics arrived there was food and wine on the table, Marshack wore a housecoat, and no books, papers or art materials were in evidence. Rocky's will later revealed he'd given Marshack $45,000 toward purchase of her co-op apartment half a block down the street from his townhouse.

Memorial services at the Fifth Avenue cathedral his grandfather built were attended by President Jimmy Carter, all living ex-presidents and all prominent presidential candidates.

Rocky's mistake may have been his name.

And all that money. He might have made the presidency if only he'd worn the face of some Brooklyn ward boss with a name like Fiorello Laguardia, Jimmy Walker, Ed Koch, or David Dinkins. ▲

LYDIA

My business was not in that ward, I was only passing through. But her face caught me as the moon catches tide. I approached her bed respectfully. *Que tal, Senorita?* I inquired. The corners of her mouth may have moved. She turned her face to the wall.

I couldn't leave. I read her chart. Amoebic dysentery. Bold, when the ward nurse wasn't watching, I touched the back of her hand there on the sheet. She turned her great eyes on mine, surprised. *Me llamo Luis,* I said. *My name is Louis.*

There was silence. Her lips opened. *Lydia,* she whispered. There was a moment more of silent looking. Then her fingers moved, greeting mine, surprising me. Her fingers were cool and without weight. They took my stranger's hand like a trusting child accepting guidance across a street. She seemed without anguish. At peace. We enjoyed a silence.

Un retrato? I asked, showing the camera. There was a gentle movement of her breath. I saw on her lips the words, *Esta bien. It's alright.*

Next day when I came by to give her a print, Lydia's bed was empty. *Pobrecita,* the nurse said. *Poor little one. Ella murio anoche. She died during the night.* ▲

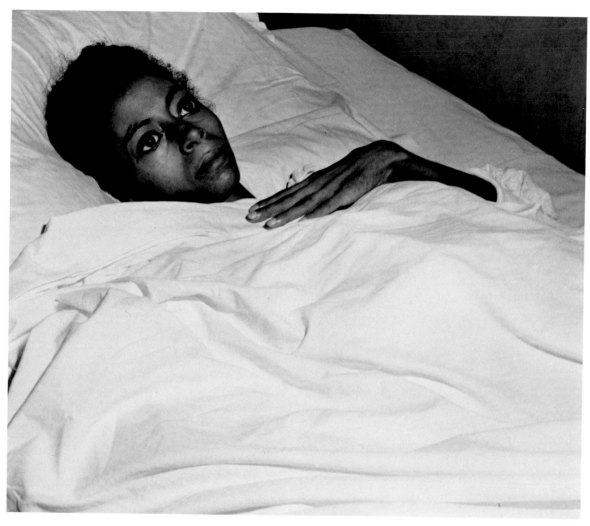

LYDIA San Juan, Puerto Rico

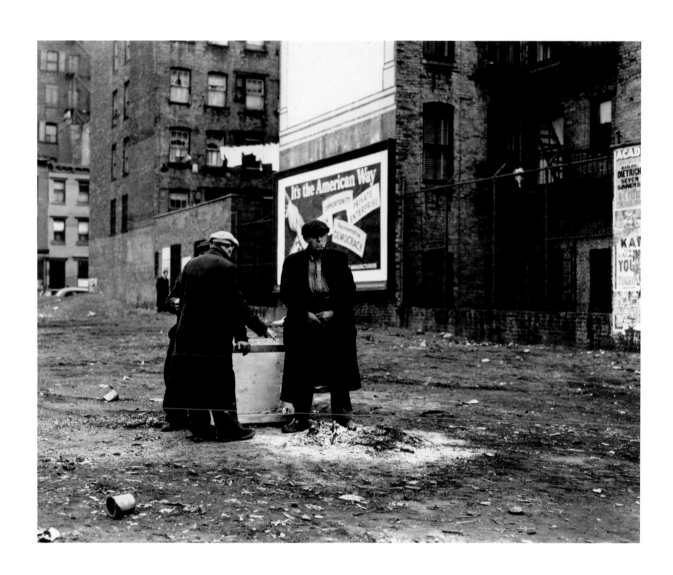

THE UNEMPLOYED

Back then, in the early 1930s, the whole American economy fell apart. Factories and stores shut down. Farmers couldn't buy seed. Mortgages were foreclosed.

The Depression was worldwide. In the United States there were 14 million unemployed. Many were on the streets looking for work. They'd be out on the highways, sometimes whole families, on foot or in jalopies, trying for another city, another state, maybe California and the orange trees.

I was a kid then but I remember those shabby slow-moving unsmiling hungry-looking unemployed men (seldom a woman). They'd come knocking on the back door of our house and always ask mother if she had some work she wanted done. She'd always say, *Why no, thank you, not right now, but maybe you'd like something to eat?*

He'd usually allow as, *Yes, M'am, I'd appreciate that.* She'd set him down at the kitchen table to whatever there was, milk, a couple of eggs, or a grilled cheese sandwich, or a helping of our family dinner cooking on the stove (which got to be serious if there were only so many corn ears or chops). Mother wasn't unique. The housewives of our country probably fed more strangers those days than the restaurants—certainly more than the government's soup kitchens.

I made this photograph of unemployed men warming themselves at a packing box fire in New York City. The billboard behind them was part of a public relations campaign by the National Association of Manufacturers. The business leaders needn't have worried. Unemployment, depression and low profits were almost finished by 1940, solved by a great new growth industry, World War Two. ▲

41

FRESHMAN

On his head the regulation *dink,* class of 1944. In his shirt pocket the 1940 football schedule. Nice clean-cut kid. A bit small for football. Might make a good 160-pound wrestler. *We might want to pledge him for the Phi Delts.*

Back then Lehigh University had compulsory military training. If you stuck with it the full four years you could graduate not only with your Engineering or Business degree but also with a commission as Second Lieutenant in the US Army.

In May of 1944 a platoon of such fresh-faced officers (including this lad?) graduated from Lehigh just in time for the final battles of World War Two—the Bulge, Arnheim, Iwo Jima, Okinawa, Air War Japan. Some Lehigh students, afraid they'd miss the action, left school early, got their commissions anyway, and their battles—Guadalcanal, Burma, Anzio, D-Day, Arlington National Cemetery . . .

Second Lieutenants were in demand those days. It was they who led the small combat units through the hedgerows and the jungles and up the beaches and flying over enemy cities. They died faster than anybody, faster than the enlisted men, the captains, the colonels, the generals, even the civilians.

It was just like the movies: *Follow me, men! Do you wanna live forever?* ▲

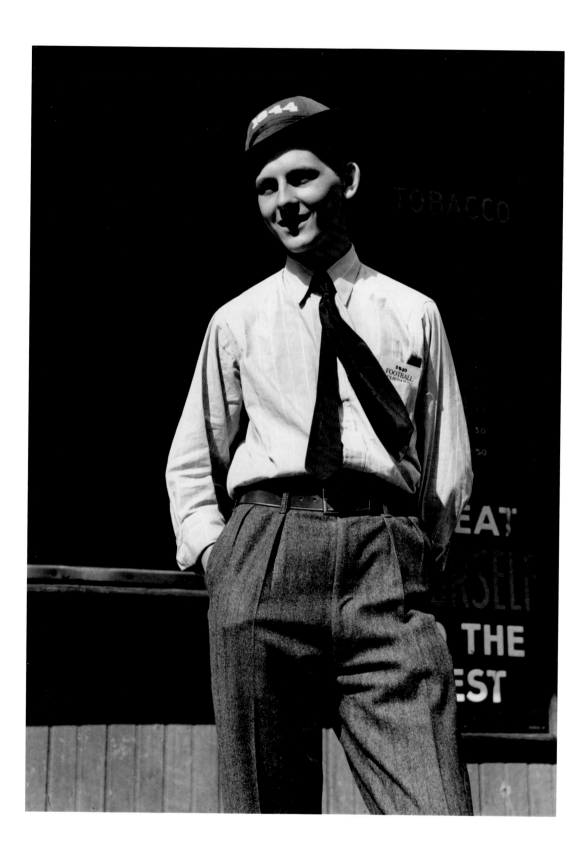

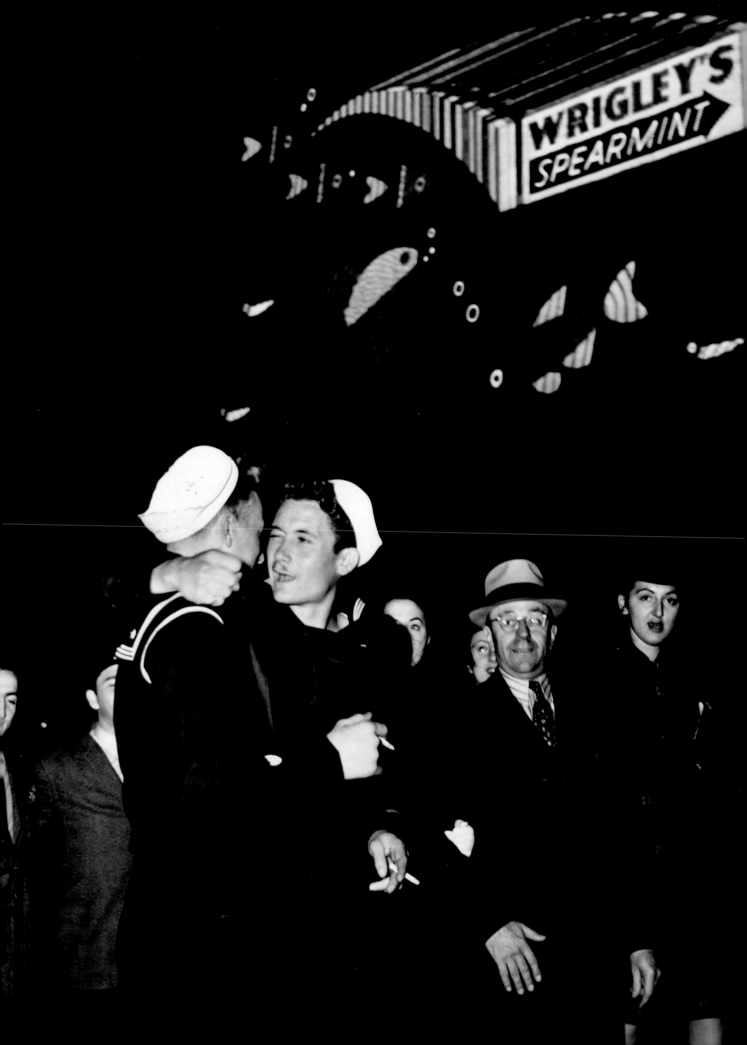

SOME SHELLS SCREAM, SOME
WHIZ, SOME WHISTLE AND
OTHERS WHIR. MOST FLAT-
TRAJECTORY SHELLS SOUND
LIKE RAPIDLY RIPPED CANVAS.
HOWITZER SHELLS SEEM TO HAVE
A TWO-TONED WHISPER. LET'S
GET THE HELL OFF THIS SUBJECT.

Bill Mauldin

two

WORLD WAR TWO

DRUNKEN SAILORS Times Square

PILOT

Why is this man smiling? Well, why not? Do you think war is hell? It's not. That's part of the problem. War is fun, adventure. Especially for those who haven't seen much of it yet. Especially for those who make it their profession. Anyway, the human spirit is durable, some would say indomitable. If you survive battle, terror can be followed by smiles.

This soldier was a pilot for the 10th Air Transport Command. Name, unit and hometown? Don't know. I photographed him on an airfield in Assam, India. Insignia on his shirt accredit him as a pilot and, in rank, a captain. His job was to fly unarmed two-engined transport planes on supply and rescue missions behind Japanese lines in Burma. And he flew cargo and soldiers over the *hump* of the Himalayas, India to China and back. There was no radar aboard those overloaded C-47s. Only compass, map, altimeter and a fading radio. Fighting for altitude, flying through fog or rainstorm or snow, a little off course, and you smash into Mount Everest. We were losing six or eight such airplanes every week. ▲

In those days the US government was more honest in its use of words. We who were in service worked for the *War* Department. Now the words have been gentled to Department of *Defense* — as in Korea, Vietnam, Grenada, Nicaragua, El Salvador, Panama and Iraq.

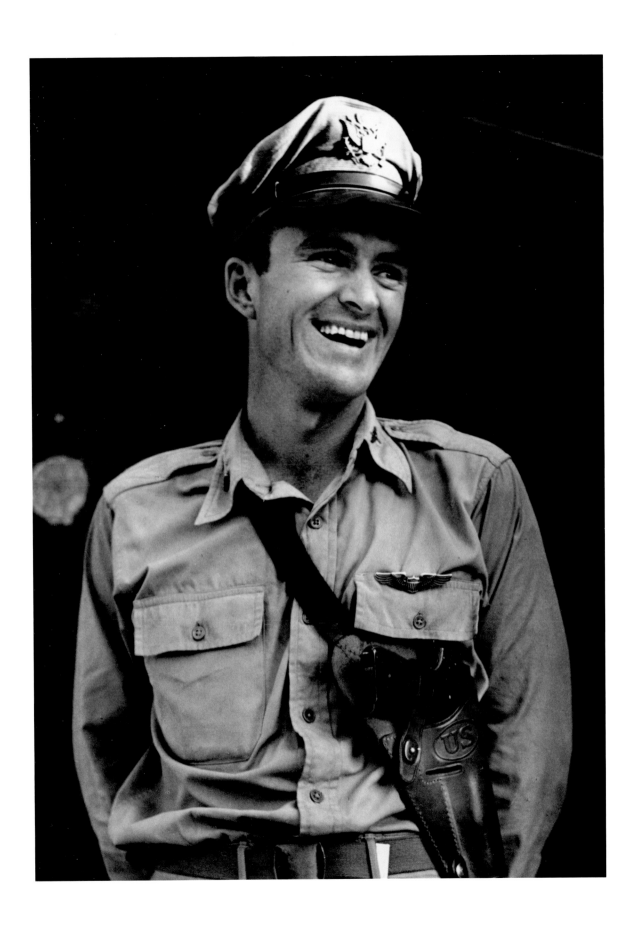

WITNESS

You ever hear the name Vincent Sheean? I asked my UCLA writing students. They all said no. So much for fame.

Vincent Sheean was the most celebrated journalist-historian of his time. He had an uncanny prescience for being present at the turning points of history. 1922, Mussolini's march on Rome. 1927, the first communist revolution in China. 1937, Czechoslovakia when the Nazis marched in. He saw France fall, London under Nazi bombs, the founding conference of the United Nations at San Francisco.

Sheean squired the young Edna St. Vincent Millay around Greenwich Village. Buddied in Paris with Picasso, Gertrude Stein and Sinclair Lewis. Got shelled and drunk in Madrid with Robert Capa and Ernest Hemingway. He published 20 non-fiction books and seven novels. His best-known work was an autobiography, *Personal History.*

I met and photographed Sheean in the spring of 1944 aboard a battered C-47 bound from India to Kunming, China. Amid bales and drums of war supplies, we were the only human cargo. A tall gray-haired army major then, he was surprised I recognized his name.

Planes in those days were not pressurized. We had one walk-around oxygen bottle between us, shared tokes on it as we flew over the Himalayas. *Better than beer,* Sheean said, passing the mask and bottle. I learned later his mission to China was intelligence, to report directly to Washington on the coming B-29 operations against Japan.

I flew on the first B-29 mission. Sheean watched our takeoff, and our return—13 hours later, fewer in number. He flew out himself on a later mission. ▲

1899-1975. Vincent Sheean was descendent of refugees who fled the Irish potato famine of 1848. Married, divorced and remarried the same woman, Diana Forbes-Robertson. Two daughters. Died in Italy of lung cancer (he'd been a smoker).

After the assassination of Mohandis Gandhi, which he witnessed, Sheean wrote: *I have called myself an atheist, but I don't really know what the word means. Through the tears that blur my eyes I can see that perhaps it means nothing, that all men, whatever they call themselves, have the same hope . . .*

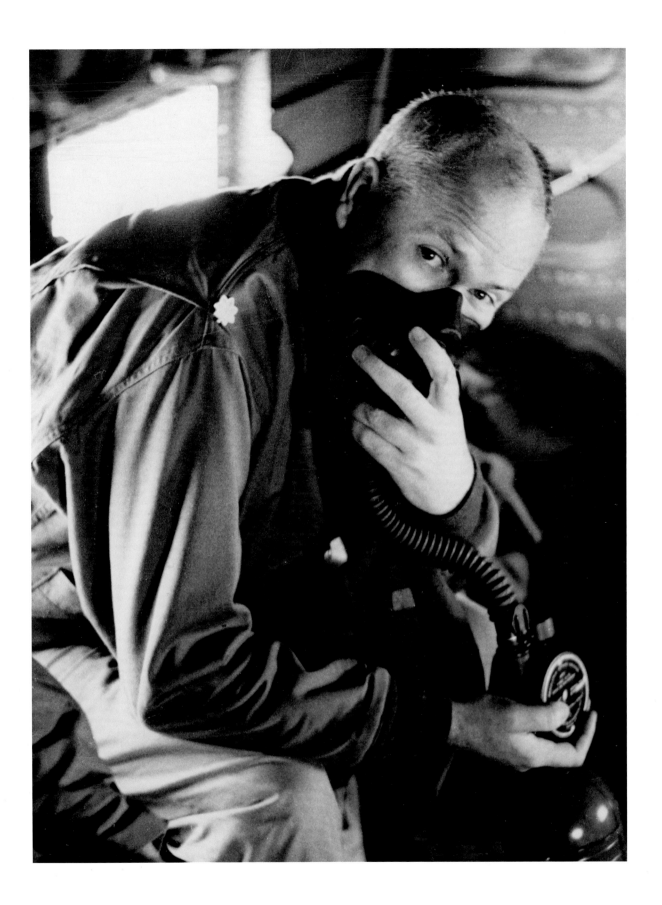

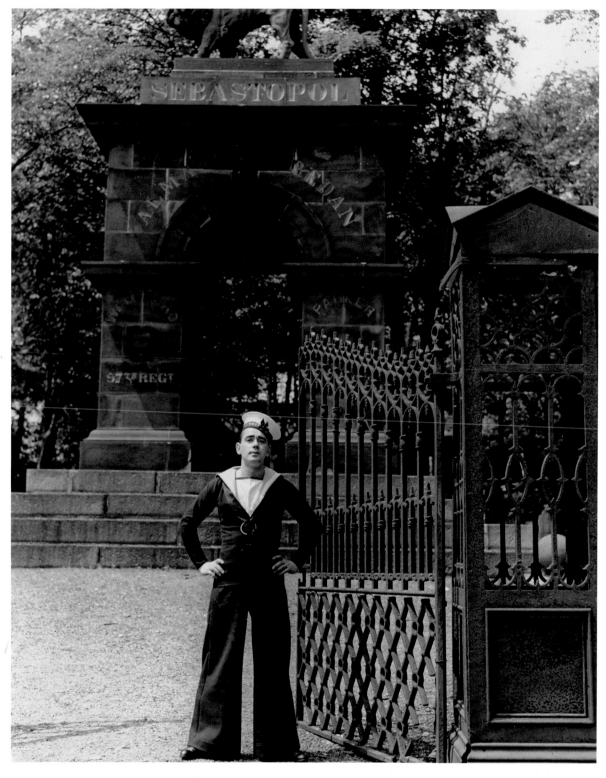

ROYAL NAVY MAN Halifax, Nova Scotia

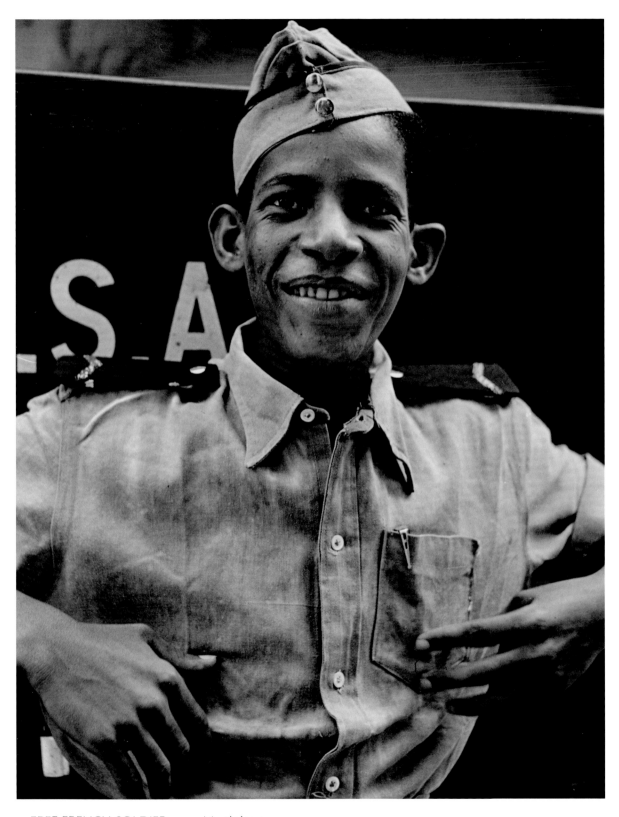

FREE FRENCH SOLDIER Martinique

OUCH! OUCH! OUCH! OUCH! OUCH! OUCH! OUCH!

When you cross the equator for the first time aboard a US Navy ship it's traditional you get initiated by Captain Neptune and his pirate crew. You run the gauntlet and get whipped by rows of sailors swinging wet hard-stuffed canvas shillelaghs. It hurts. If you hold your hands behind, like the racer in the photograph, you stand a good chance of broken fingers. If you don't, you get knotted raised welts of protesting muscle and in a few hours, large bruises. You sleep a couple of nights on your belly, which is hard to do in a hammock.

Aboard the small aircraft carrier Mission Bay, en route in 1943 from Brooklyn Navy yard to Karachi, India, there was a special situation. Instead of flyable attack planes, the Mission Bay carried a cargo of new knocked-down P-47 fighters for delivery to China. Also aboard were several hundred US Army men. All we soldiers were tenderfeet. All the ship's Navy crew were Neptune's veterans. Oh boy! Good clean sadomasochistic fun! In addition to the shillelagh gauntlet, the Navy pirates squirted into the front of each soldier's drawers a pump gun full of grease. And maybe shampooed his hair (what was left of it) with grease. Then he got violently hosed with salt water down a canvas tube to the elevator deck below. There, if he could walk, he was at last proclaimed a proper and equal Citizen of the Sea.

The experience makes a nice memory. It did help pass a boring time. 800 men on a little ship, sleeping in hammocks two feet apart five deep, between sweating steel decks in tropical waters, eating every meal out of greasy mess kits, waiting in lines for stinking toilets, usually forbidden the open-air upper decks because there was no room. We did get a few hours shore leave in Racife, Brazil, and also in Cape Town. Off Madagascar the ship suddenly took violent evasive action, keeling over maybe 25 degrees. Nazi submarine attack! We dropped depth charges, watched the sea explode. Two South African destroyers came over the horizon fast and escorted us to safety. ▲

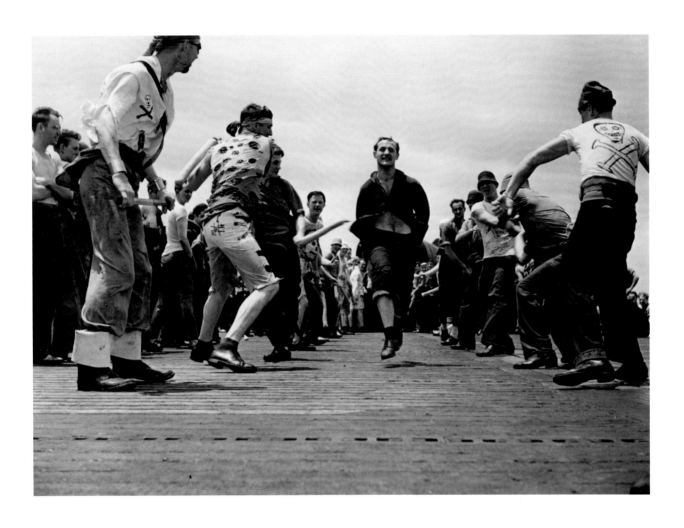

STANLEY'S TATTOO

Courtmartial testimony of seaman Oliver Hennessey, USN #10405412:

Yes sir, we sure were drunk. Stanley was drunkest of all, sir. He couldn't walk. He was unconscious in a bedroom. So Ishkanian and me we took his arms and legs to carry him back to the ship. Well, sir, we come to this tattoowallah and he—

Well, sir, yes sir, it was my idea. Anyway, the needle woke Stanley up. He didn't object. He enjoyed it. He just wanted to know what the tattoo was going to be, so—

Sir, we told him it was an anchor and a rose.

But sir, soon's it was done we showed him a mirror, and sir, he laughed, we all laughed, hysterical so we couldn't hardly breathe. Stanley was laughing most, pounding his foot on the floor, laughing to bust his ass.

So I don't see, sir, why he's bringing charges against us now. ▲

THE GENERAL

One-time Louisiana schoolteacher Claire Chennault had been so unlikely a military leader that the US Army retired him as a captain in 1935 because of a hearing disability. He'd flown noisy open-cockpit planes during World War One.

But Chennault was a dogged ambitious soldier. He got himself appointed in 1937 civilian air advisor to China's Generalissimo Chiang Kai-shek, who was then fighting off a Japanese invasion in the east and a Red Chinese revolt in the north. In 1940, Chennault flew to Washington (still officially neutral) where he worked a deal with President Roosevelt for 100 US Army, Navy and Marine fliers to *volunteer* for combat in China. About 100 new American P-40 fighter planes volunteered too. The United States was still officially neutral.

This American Volunteer Group wore Chinese uniforms, painted their P-40s with fierce tiger-shark faces, and were soon famous as the Flying Tigers. When the Japanese hit Pearl Harbor, Chennault's adventurers were the first effective American force able to fight back. From December 1941 to July 1942 (when they put on US uniforms again), the Flying Tigers revolutionized the tactics of air warfare. At a cost to themselves of 32 airplanes and 10 pilots killed in action, they were officially credited with destroying 299 Japanese planes and approximately 1500 Japanese pilots. bombardiers and navigators.

Chennault was a survivor. In the political bucket of worms that was Asia those days, he never seemed to make a professional or political mistake. While higher-ranking US generals and ambassadors got bounced back to the States, he happily hung on till the end of the war—and afterwards.

In July of 1944 I talked for an hour with Major General Chennault at his headquarters in Kunming. He was commander then of the US 14th Air Force. He returned my salute with a handshake—which was a good way to earn a soldier-journalist's confidence. He had an old coach's face, a hoarse voice, and was hard of hearing. My principal questions had to do with air generalship. What were the tactics that made Chennault's fliers so effective? Wasn't the Japanese Zero faster and more maneuverable than any American fighter? With the Burma Road closed, how could enough supplies be flown in to accomplish anything?

I take a broad view of the use of air, Chennault said. *I've found that air can be used as infantry, as machine-guns and as artillery. In Burma we've used fighters as bombers. Over the Hump we've used bombers as fighters, shooting down 11 Japanese fighters on one round trip. Up at Tung Ting Lake our P–40s cut Japanese steamboats in half by strafing alone. . .*

Yes, the Zero is small and light. It can out-climb and outmaneuver any fighter we've got. But we give our pilots specialized training. We refuse to maneuver. We avoid turning combat. Instead of single airplane dogfighting like the

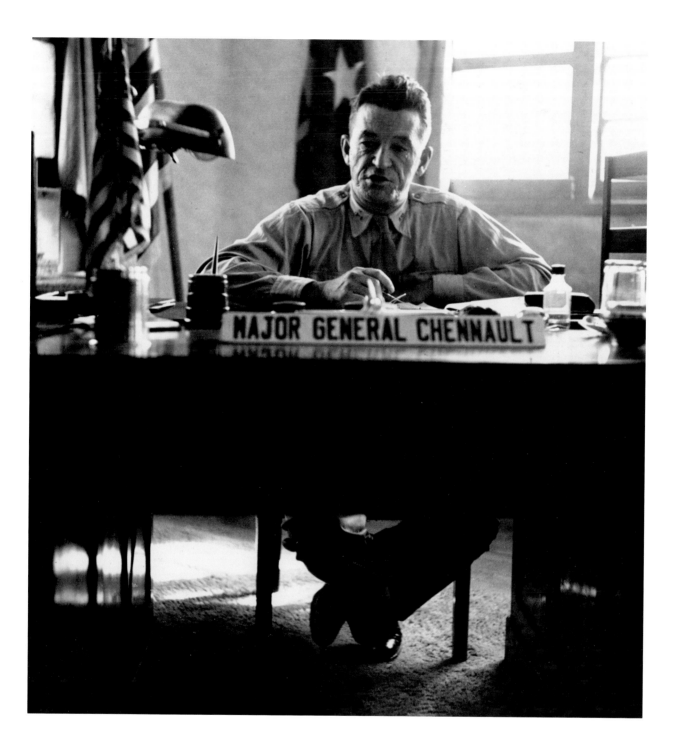

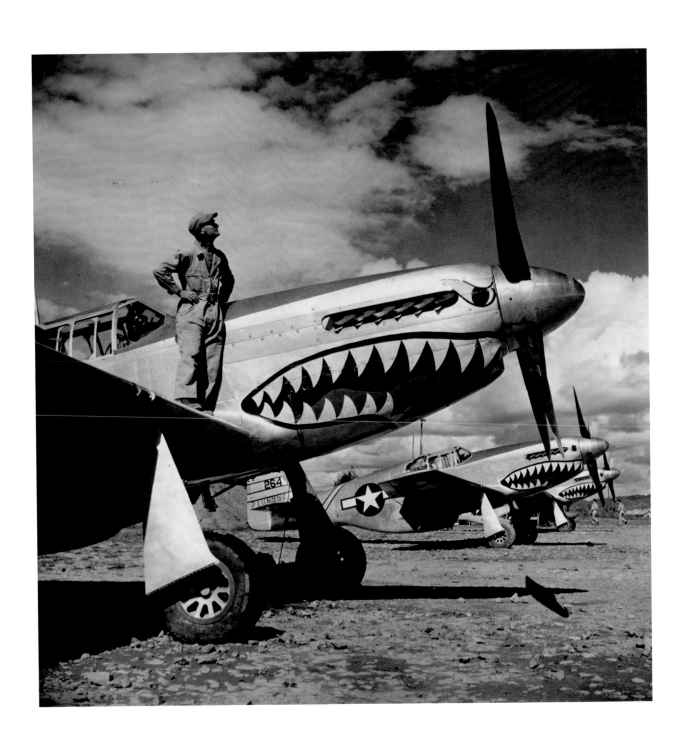

First World War, we insist on two-plane teamwork. American aircraft can dive faster than the Zero. We have superior straight-away speed and heavier firepower. We never try to stay on the tail of a Zero. We hit the Zero hard in a straight pass and get away fast . . . These principles produce safety for our fliers and losses to the Japanese . . .

The 14th is the most remote US Air Force, Chennault said. *We're blockaded. Everything we get has to be flown to India and then flown across the Hump. I don't expect we'll ever get enough so my operations can be decisive. But the attrition we inflict is considerable. If we can support the main blows from the Pacific by containing a large Japanese air force within China we'll have done our job.*

Old deaf Claire Chennault died a three-star Lieutenant General in New Orleans, 1958. He'd helped Chiang and his Kuomintang army escape the Reds and take over Taiwan. He'd flown for the French at Dien Bien Phu. He'd performed certain contracts for the CIA in Indo China. He'd gotten rich from postwar operations of the Flying Tigers commercial airline. He'd received top decorations from the Chinese (Taiwan), French, British, Polish (yes) and American governments. He was father of ten children by two wives.

Chennault's second wife Anna Chan, daughter of a Koumintang diplomat, was for many years of her widowhood the *Dragon Lady* of the China lobby in Washington. Madam Channualt's physical elegance, her powers of wit, and her silk-on-steel advocacy were said to have charmed presidents, switched congressional votes and helped delay US recognition of the Peoples Republic of China. ▲

GENERAL CHENNAULT WAS CAPTAIN OF THE OFFICERS' BASEBALL TEAM. This day they were defeated by the enlisted men.

59

BAKSHEESH!

In 1943 there was a famine in India, although the warehouses of Bombay, Delhi and Calcutta were filled with rice. More than one and a half million died. In the province of Bengal alone 50,000 men, women and especially children were dying of starvation each week. The famine was man-made: by rice profiteers, by money lenders, and by allied governments preoccupied with waging war.

The Indians are a peasant people. As the rice they had cultivated disappeared into city warehouses, as its price rose more than 1000%, the hungry peasantry deserted their fields and flooded into the cities. They lived in the streets. They begged. They clawed through garbage, ate grass. Strangely, they did not steal much. They died quietly, victims also of a fatalistic caste system that taught them not to complain.

Every morning at earliest dawn, before the clerks, coolies and military came to work, a fleet of government *disposal trucks* roamed the streets and riverbanks, picking up the night's harvest of human bodies.

The little survivor in this photograph slept, with others like her, on the cement sidewalk behind US Army headquarters in downtown Calcutta. This was a good location for her trade.

Sahib, baksheesh! (Alms).

You want jolly-jolly, Sahib?

You no want me I take you my seestaire, she thirteen, very clean, Sahib, virgin girl from country.

You give me seegarette, Sahib? ▲

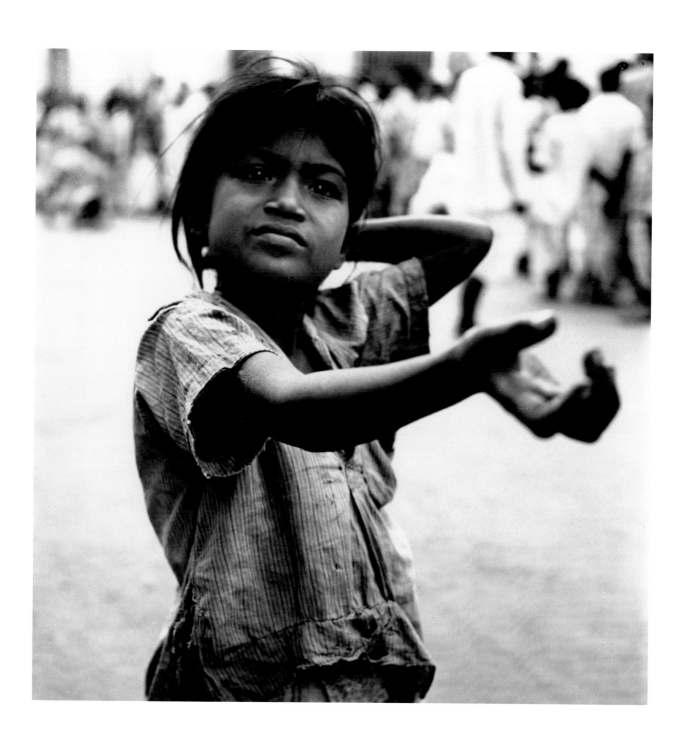

NEHRUDEEN

She followed wistfully at a distance as I photographed my way down the narrow Calcutta street, through the watching dusty excited children. Finally, courage up, she confronted me. *You make my picture, teek? Teek,* I agreed.

She was superb. Her repose and almost-smile seemed at once male and female, sensual and spiritual. Her classic features were like ancient sculptures of Lord Buddha. Only her lustrous hair looked contemporary. It seemed windblown. But there was no breeze that foetid pre-monsoon day.

Suddenly the child laughed merrily, and her friends laughed, as she tore from her head all that beautiful hair. It was a wig. She was a boy. I laughed too, joining the fun.

My name is Nehrudeen! he said, gleeful. He'd played a fine joke on the Yankee soldier.

The illusion of the wig had been extraordinary. This was no street boy's toy. It was real hair expertly sewn, valuable.

My father make this, Nehrudeen said proudly. *He is a maker of wigs, by profession.* ▲

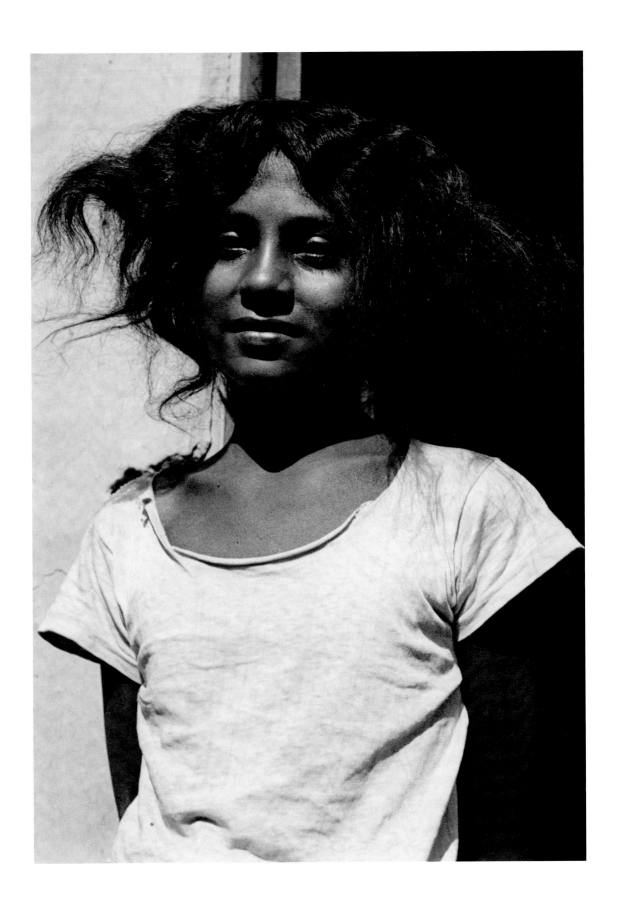

WIGMAKER

Mr. Das sits on the threshold of his home, pleased that his son has made the afternoon interesting by bringing home an American. There can be conversation now in English. And cigarettes.

Yes, I make wigs. My father taught me and I teach Nehrudeen. My father was a great wigmaker. He worked even for princely families, for royalty . . . Before this war I had my own shop, near the Great Eastern Hotel. Now nobody wants my wigs. It is this war . . . How surprising it is, sir, that many women lose their hair. Sometimes the cause is sickness, or age. Some women go quite bald, just like men. Such women are grateful for my skill. It is a service . . . I buy live hair from poor young women. I cut it and sew it for rich old women. That is why I am a socialist, like Nehru, I see how things are . . . Oh yes, for the young women it is also good. I pay them many rupees so they can feed their children. The hair grows back soon anyway, of course not so long . . . No, no, my wife says she is ashamed to be in a picture, she must go cook. The picture will be destroyed by her face, ha, ha. But I will be in your picture.

So there on his doorstep forever sits Mr. Das, wigmaker, and by his side his wife's departing foot. Mr. Das' own hair is finely waxed and combed. On his right bicep he wears a holy amulet the street healer said would cure the persistent sores on his other arm. He likes the American, enjoys talking about large affairs with him, one worldly-wise citizen to another. ▲

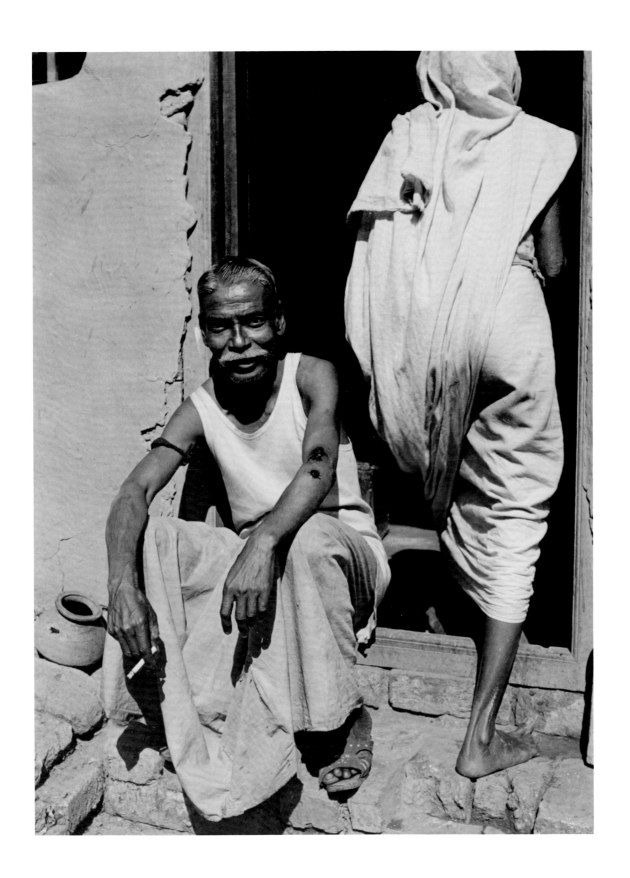

WOMAN

Brought to bay in her kitchen by the American, with the complicity of her husband, the woman squats on the mud floor before her open hearth, also of dried mud. Ventilation and a shaft of sunlight enter through a hole in the roof. She has several pots and paddles, a few small boxes and sacks of food. A glass jar contains milk.

She speaks no English. She does not read or write any language. She is only a woman.

Ancient, in her white shroud-like garment, she regards my camera's eye across a chasm three thousand years wide.

Yet we come to recognize each other. She smiles. Her husband says she says she is honored by my visit. I receive tea. ▲

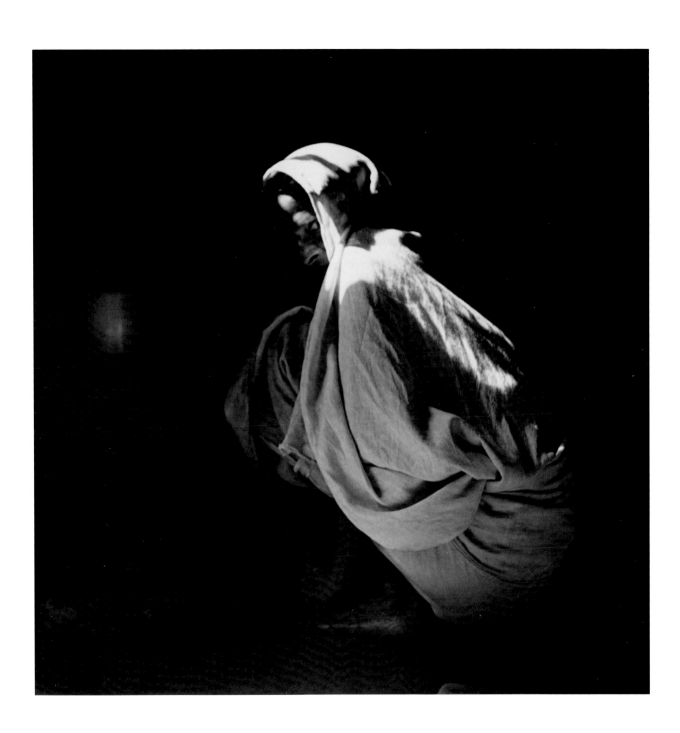

TWO YEARS

The real enemy in war is boredom. Ask any veteran. The months amputated off your life become years. You live in a molasses river of waste, delay, incompetence and drunken men.

For every soldier, sailor and airman in battle there have to be a hundred driving trucks, cooking, saluting, getting drunk, telephoning, teaching, arming aircraft, fixing submarines, getting drunk, washing glassware in the officers mess, inspecting genitals for VD, getting drunk, writing and reading and publishing tech manuals, travel orders, inventories, requisitions, promotions, court-martials, intelligence reports, payrolls and regrets to next of kin. The patriotic leering jokes of the visiting millionaire Hollywood comedian aren't funny. It doesn't help much to hear the fat priest from home bless the murdering at Christmas.

It's good to check out the foreign cities when you can, find the clean women and restaurants, see if the local gooks make any souvenirs worth taking home. The gold *hash* marks on the soldier's left forearm each signify six months service abroad. His four hash marks equal two years, so far.

The average life span among ricksha pullers, who all develop enlarged hearts, was said to be 32 years. ▲

BOY SOLDIER

The closest I came to getting killed, so it seemed at the time, was a meeting one night in China. His scream hit me from the dark, punctuated by the doomsday clang of a rifle bolt slamming ready. A Japanese infiltrator! Would he shoot me? My hands leaped to the sky. *Meygwaw bing!* I yelped. *American soldier!* He spoke in guttural soprano: *Shut up! Turn around!* I knew six words of Chinese, none of Japanese. But I understood this man's commands. His hand yanked my .45 from its holster. Something sharp butted my lower spine. *Walk!* I did.

Those days the Japanese occupied China's major cities and all its coast. We Americans, with some companies of dispirited Chinese infantry, operated supply and bomber bases in the interior. This night I was at the forwardmost base, Kweilin.

My captor marched me to a sandbagged guard shack. A Chinese officer sat inside at a desk by a telephone. A carbide lamp hissed white light. He looked up, shocked. *I apowogize, suh,* he said. *You put down you hands.* I looked over at my original conqueror. He was hardly five feet tall, his neck chicken-scrawny inside a ragged too-large uniform. He was a boy! Twelve? WHOP! The boy soldier fell, spurting blood from his nose, scrabbling for the door. The officer hammered him again, kidney, with the butt of his carbine, aided his exit into the night with a kick. The officer laughed, turning to me proudly for approval. I understood then why most Chinese hated Chiang Kai Shek and his army government (and, later, why China fell so easily to the communist troops of Mao Tze Dong).

That evening when the moon finally rose over Kweilin's fantastic conical mountains, illuminating the target, the Japanese made a run. In six small bombers they flew just above range of the .50 caliber machine-guns, our heaviest anti-aircraft weapon. They demolished a barracks, burned two shark-nosed P–38s, and ripped up our airstrip. No casualties, since most of us took cover in caves.

Next morning there was the boy soldier, limping. They'd left him sleepless on 24-hour guard duty. *I'm sorry,* I said. He said nothing. I gave him two packs of Camels, each worth about $500 Chinese that week. He accepted the cigarettes, said nothing. *Photo?* I asked, raising the camera. He looked me in the eyes. I made the picture. His regard across time and cultures seemed to me innocent. I felt we saw and honored each other that moment, our difference and our likeness. ▲

Two weeks later Chinese troops guarding the approaches to Kweilin were routed by Japanese infantry. We Americans evacuated everything we could by air and railway, blew up and burned the rest. The gasoline dump, all those bombs, bullets, and buildings made a magnificent conflagration. I hope my little soldier friend got out okay.

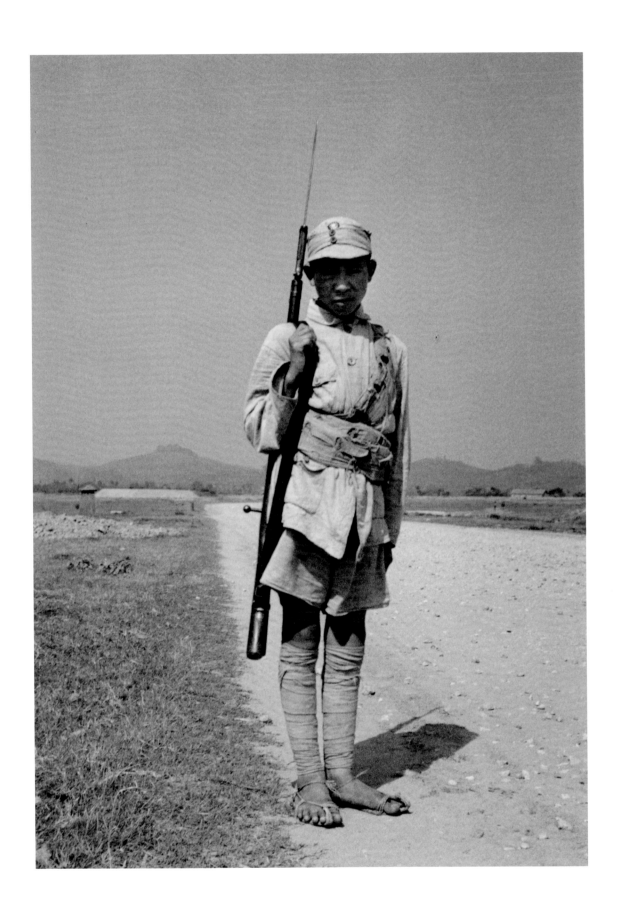

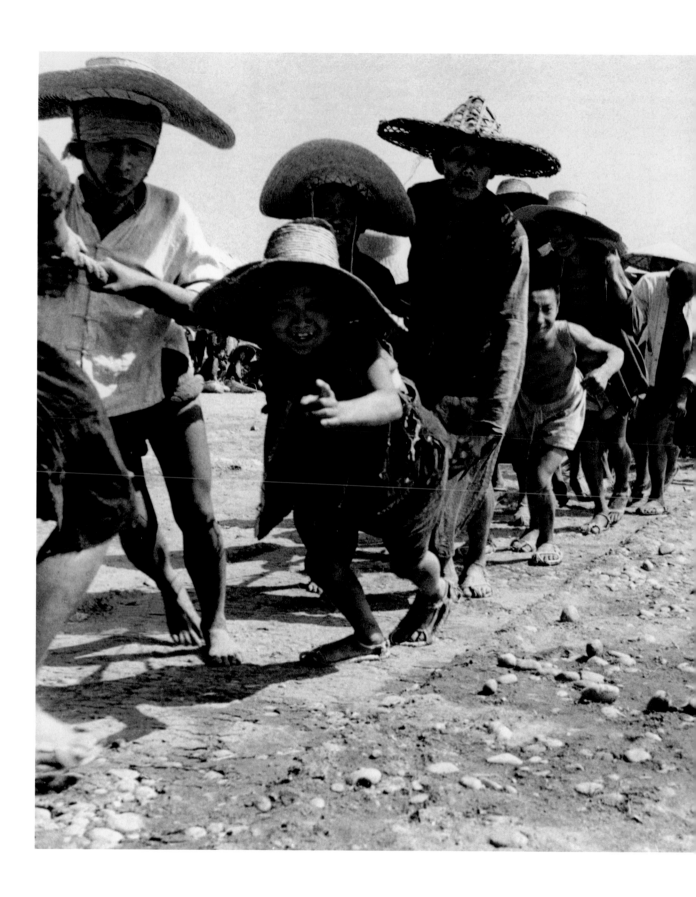

MISSION TO JAPAN

The B-29 in its day was the largest heaviest warplane in history. It needed longer airstrips for takeoff than had ever before been built. This heroic construction was accomplished at Chengtu, China, by hand, in less than four months. A few American engineers and 500,000 Chinese women, old men and boys too young for the army did the job.

Women carried water-worn rocks in baskets from streambeds to the building site. Men and boys sledged the bigger rocks to bits, spread tung oil to hold earth and rocks together, and leveled the fields to American tolerances pulling ten-ton iron or stone rollers by ropes. Many workers died in construction accidents, the most terrible of which were deaths under the huge rollers, which could not be stopped quickly.

I flew from Chengtu field on the first B-29 raid against Japan. On my knees, watching out a plastic bubble, I saw the great airstrip unroll under the pounding and roaring of our huge Superfort. Earlier, one heavily-laden B-29 had failed to rise by runway's end, crashed in all its own bombs and gasoline. A blast of mythic fierceness.

But for us, the green end of the airstrip danced by ten feet below. Rice paddies fell beautifully away, glinting in the golden China afternoon . . .

We're approaching the target, a voice squawked on intercom. We all struggled into canvas-on-steel flak suits, strapping them over our parachute packs. I watched over the navigator's shoulder a small circular fluorescent screen. Our secret invention! Radar! Not yet known to the enemy. There through the black night, like a

magical X-ray movie, I saw the coastline of the Japanese island of Kyushu appear. A thrilled scared American kid, all I could think of was Raymond Massey in the H.G. Wells movie *The Shape of Things to Come*.

The Japanese blackout below was perfect. Then dead ahead—a faint glow. Anti-aircraft searchlights over our target city, Yawata. The fingers of light suddenly grew bright, dangerous. One touched our tail. We escaped into clouds.

Flak! Bursts of exploding shells filled the air around us. Our craft trembled. Bomb-bay doors swung open . . . *BOMBS AWAY!* was the cry. *Thar! Thar she blows!* I thought, crazy. *It's Moby Dick, the white whale!*

Relieved of weight and responsibility for precision, we suddenly accelerated, flipped a U-turn, and raced back toward the Yellow Sea. We'd been one of the first planes over target. Later crews reported columns of smoke and fire rising 5000 feet, visible from 50 miles . . .

Captain R. A. Harte, high on issue benzedrine, face aged ten years in thirteen hours, set us down again on Chengtu field easy as a mother cribbing her child. In the debriefing rooms were coffee, egg sandwiches, whiskey and questions.

We'd lost four B-29s. 48 men. One bomber, seized over target by searchlights, was seen going down trailing fire. Press reports (including mine to the Army weekly magazine YANK) said 20% of Japanese steel capacity had been destroyed. We all quoted Brigadier General Kenneth Wolfe, who hailed this mission as *the beginning of the organized destruction of the Japanese industrial empire.* ▲

I learned in Washington after the war that most of our bombs missed the steel works that night. The press, including *Yank*, had been fed war-time misinformation. Most of our bombs had fallen on the flammable bamboo homes of Yawata and incinerated hundreds of civilians.

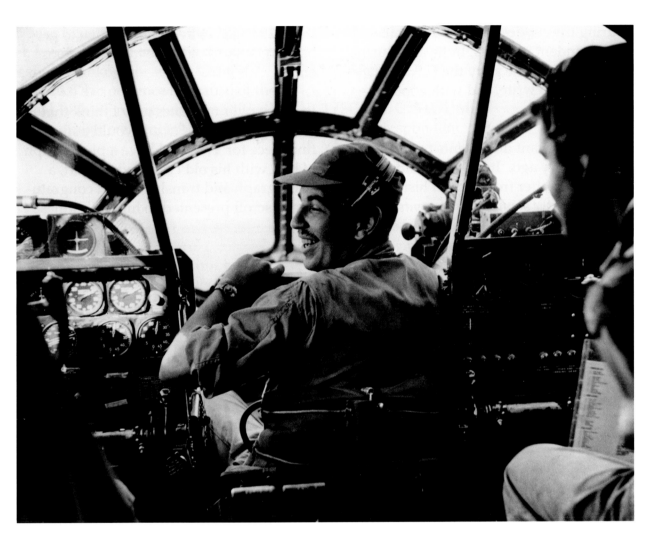

B-29 BOMBARDIER. He's just sighted home field after a 13-hour mission.

SCROLL PRESENTED TO T/SGT. BENKO CHRISTMAS 1943 BY CHINESE FRIENDS

Ding-hao, ding-hao, ding-ding-hao. P-38 raises above the clouds. P-40 is as bold as hero. P-51 is smart, and the Liberator is constructed with intensive labor. Sergeant Benko, who was the skillful gunner was an expert in shooting. When the enemies' planes were chasing into the course of shooting, they were unable to escape while they were sighted. The tail guns, shooting without stopping, rendered twenty Zero fighters disappear. No one can compete with this highest record. Here comes the enemies' last day. Boys of United Nations should be joyful because victory is drawing near.

✳ ✳ ✳

Excerpts from T/Sgt. Benko's letter to his wife

. . . The raid was a success and we were all returning when one of our engines quit dead and then another one started to quit. We started throwing all excess weight overboard, but kept losing altitude so we were told to bail out . . . I've never heard such quiet-

ness as I did after I had left the plane and pulled the ripcord. Here I was floating way up there in the air and not a bit of sound anywhere. I could see Dykes in his chute a little way off. I looked at the plane fading in the distance and could see other crew members opening their chutes. Gosh, I sure felt kind of lonesome up there . . . no sensation of falling but the earth seemed to be moving up closer . . . I landed on a hillside safely and found myself in thick brush about ten feet high. I got out a big knife which we carry in our emergency kit and cut my way back up to the top of the hill where I spotted a trail, also three friendly natives looking around to find where I had landed . . . They took us down some narrow mountain trails to a little five house village . . . Supper consisted of rice and chicken and tasted pretty good . . .

So, here I am back again and waiting to go on another raid, whenever they decide we should go. Some of the boys aren't very anxious to go but will whenever they are scheduled. I must

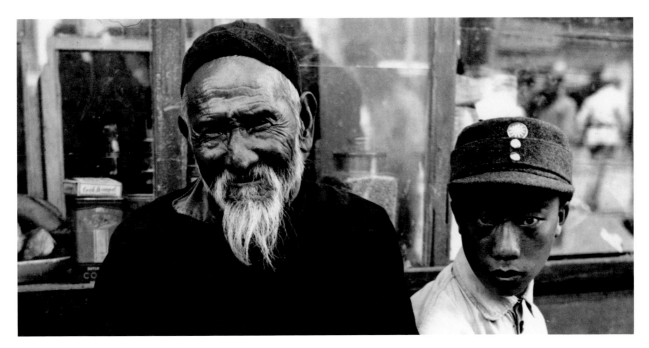

GRANDFATHER AND SOLDIER GRANDSON Chengtu, China

say I like it. I never see or think of the other guy shooting at me. I just get a thrill out of shooting at them, and a bigger thrill to see them go down in smoke. I also figure the more times we bomb the enemy and the more zeros we shoot down just means that much sooner I'll be back to the good ol' USA and the one I love . . .

*　*　*

Sgt. Benko did not return from his next and last mission.

*　*　*

Headquarters
Fourteenth Air Force
A.P.O. 627

6 January 1945

SUBJECT: Proposed Story on Sgt. Benko.

TO: T/SGT. Louis C. Stoumen, YANK Magazine, APO 465, India-Burma Theater.

In reference to inquiry letter of 8 November regarding story "The Legend of Sergeant Benko" you are advised that a full security stop has been placed on Sgt. Benko.

THOMAS R. HUTTON,
Lt. Colonel, A.C.
Public Relations Officer.

*　*　*

If indeed *guerrillas* had reported seeing Sgt. Benko being paraded in chains through the streets of Hankow or Canton (then occupied by the Japanese invaders), Colonel Hutton was correct in placing *a full security stop* on Sgt. Benko. Indeed, if Benko were in any circumstance

prisoner of the Japanese, publication of his history as an American gunner credited with 20 Japanese aircraft kills could have been his death warrant.

What was not said in any of the above documents, all of which were subject to wartime censorship, was that the *natives* and *guerillas* referred to were **Vietnamese.** It was common knowledge among American intelligence officers and flight crews that in rugged southeastern China, which borders on northern Vietnam, Vietnamese soldiers were regularly rescuing U.S. airmen crashed or shot down behind Japanese lines and delivering them to American bases in the interior of China.

The Vietnamese, themselves fighting a war of liberation against the French, were fighting on our side. Ho Chi Min was their George Washington.

After the war we betrayed them, as American presidents and congresses, misinformed by our biased racist diplomats, supported the French in their final losing battle at Dien Bien Phu. We ultimately spent fifty thousand American lives and the lives of more than two million Vietnamese, Cambodians and Laotians in a genocidal war that decimated those countries and so damaged the American economy and moral sense that to this day we have never quite recovered. ▲

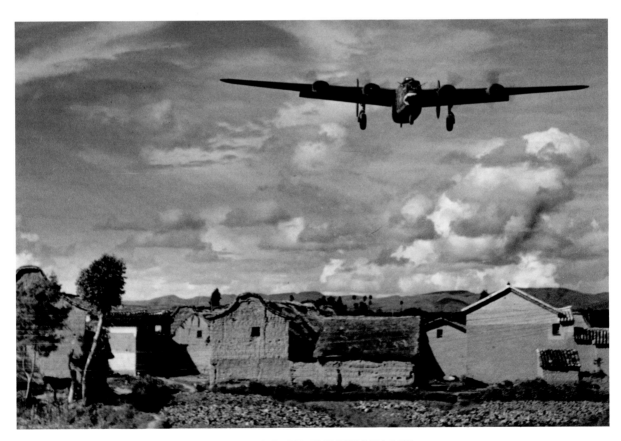

B-24 BOMBER COMES IN FOR LANDING OVER CHINESE VILLAGE.

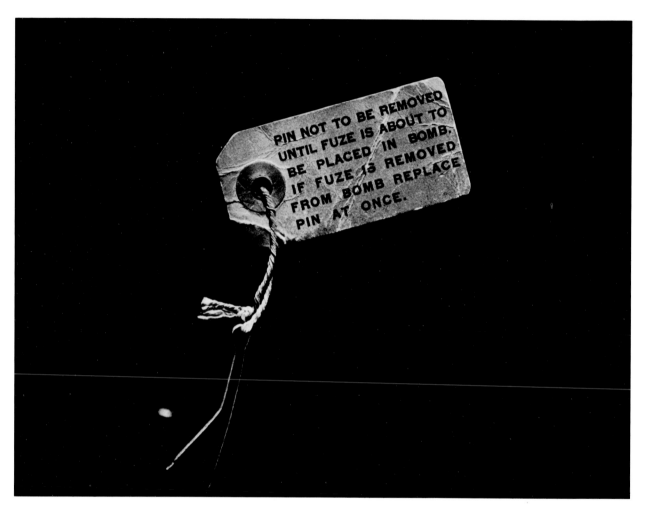

BOMB PIN Kunming, China

48-STAR FLAG South Atlantic

THE BIG SECRET

Back at all the bases and staging areas of all the air forces, armies and navies were whores. In San Juan, where this photograph was made in 1942, and in San Francisco, Yokohama, Hamburg, Marseille, Palermo, Kirachi, Liverpool, Murmansk, Tsingtao and a thousand other ports, encampments and countrysides, the whores came out to the men like grass to rain.

They sat with slit skirts in dark bars, walked the hungry streets competitive and hopeful, worked houses approved by governments, offered themselves outside cooktents, at artillery posts, along lines of march, in the fresh ruins of cities.

And for most of the millions of young men in arms, the battles, the voyages, the tedium of training—these were only survival games. Everybody, on all sides of the war, was patriotic. They were told God was with them. But primary in the minds of these mostly very young men was—sexual feeling, sexual hope, sexual fear.

No! cried the Kansas boy on the hospital ship off Tarawa, struggling up through shock and morphine, afraid not for his life but of the surgeon's scalpel cutting away burned flesh near his groin.

Patrols carrying carbines and light machine-guns through jungles danced precisely in their point man's footsteps, fearing not enemy soldiers but little Japanese anti-personnel mines that exploded upwards. Fighter pilots and jeep drivers worked sitting on their steel-plated flak jackets. Commanders of all political persuasions fired the fierceness of their men with false, sometimes true, tales of the enemy castrating prisoners.

When the attack was over, the flight returned, the ship in port, then life began: the drinking, the brawling, the lovemaking—in the upstairs hotels, in the alley houses off Kensington Square, on the park grass in Recife, on the beaches of Honolulu, on the embankments of Vancouver, in the pleasure houses of Calcutta's Karaya Road. There life was lived. Men, briefly free of the company of men, knew, in their disarmed nakedness, women. Flesh and spirit were touched. Consciousness was changed. It was in these brief beds not the chancelleries that the old societies of the world were forever changed. United Nations under the sheets.

The big secret these men never told their wives, or the girls they later married, was that they hadn't only bedded these foreign women, they'd in many cases loved them. The brown girls and yellow and white and black had been dear to them in times of youth and need. The transactions had been honest. Money for love. Or C-rations for love. Or cigarettes, chocolate bars, silk stockings from the PX. No arguments about morality. No months-long courtships. No contracts. Often the exchange came to be love for love.

In the populous poor lands where most of these matters happened, the young women

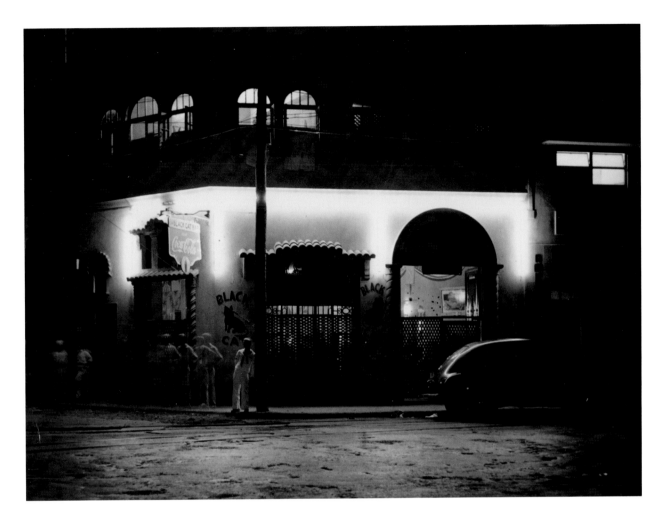

BLACK CAT BAR AND BROTHEL San Juan, Puerto Rico

were spirited, tolerated by their societies as entrepreneurs in a difficult trade. Many were beauties, very young, with flashing eyes and proud walks. And they didn't tease like the girls back home, They laughed, drank with the boys and danced, learned foreign languages, kept clean, earned their money and saved it. Some opened their own bars, started businesses. Some married foreign soldiers. Some retired when the war was over, respected and rich. Some were thieves, rollers of drunks. Some hid grave diseases, making trouble and pain for the men.

And there were corrupted men, including Americans. Men capable only of fast contacts to boast about in barracks. Men brutalized by training and license to kill. Good soldiers who beat women, cut them up, got mean drunk and smashed their rooms.

Buy me a drink, honey? ▲

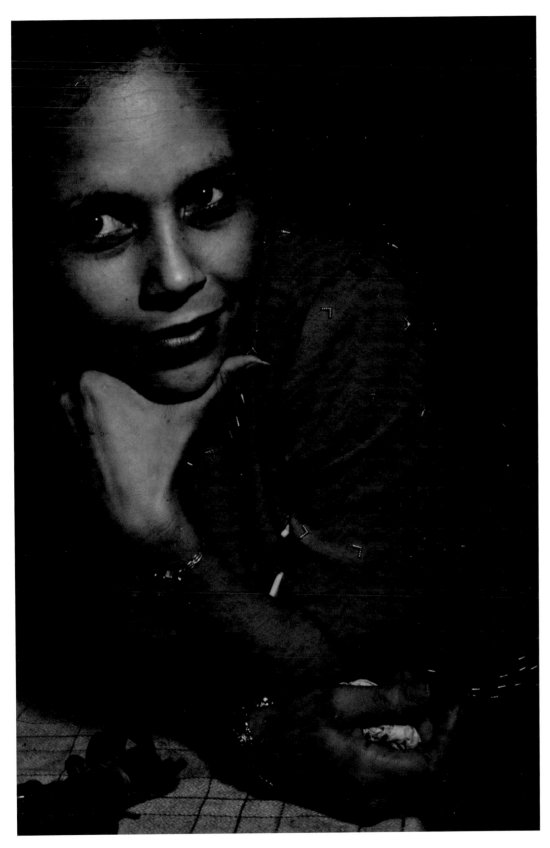

WOMAN FOR HIRE San Juan, Puerto Rico

PEACE

One afternoon in Calcutta I called the first meeting of the United Nations. In the doorway of a bar. *Have a drink, buddy?*

We were a Security Council in our cups: the New Zealander, the Sikh, the Aussie, the Chinese, the two Englishmen, the Maharati, the Pathan, the West African, the Rajput and we four Americans. Guess who's which?

We never got to declare peace. We couldn't figure a way behind our officers' backs to invite the Japanese and German enemy.

More than fifty million men, women and children *died* in that war. ▲

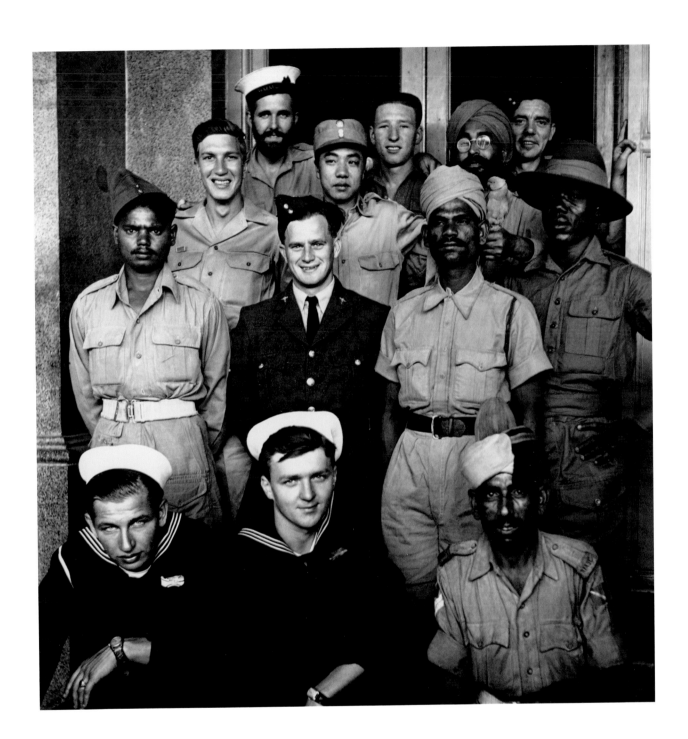

WATER BUFFALO BOY Chengtu, China

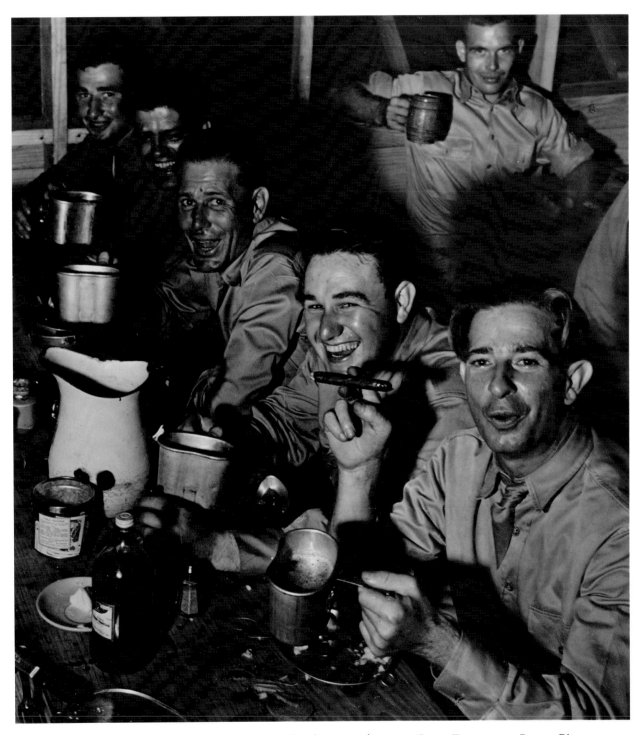

ROAST TURKEY, BEER AND CIGARS Thanksgiving dinner at Camp Tortuguero, Puerto Rico

COMMANDER IN CHIEF

The whole country cried. It was like John Kennedy's death. Like Lincoln's. As with Lincoln, the country had just come through a war with him. This time there'd also been ten years of economic suffering.

President Franklin Delano Roosevelt. He'd pulled us through the Depression, made jobs for young people, helped the poor, labor, blacks. Gave the unemployed important work rebuilding our roads, bridges, public buildings. Gave us Social Security. A rich aristocrat, he'd disciplined the bankers and brokers till they called him traitor to his class. Of course he'd promised to keep us out of the Euro-pean war, but, considering Hitler and Pearl Harbor, most of us forgave him that.

FDR was jaunty. He'd conquered polio, served his three terms in a wheelchair. Now in 1945, with the war not even quite finished, FDR lay dead. Cerebral hemorrhage. Americans wept in the streets. Everyone remembered afterwards where they were and doing what when the news came. In my case I was walking on a west side street of New York City, still in uniform, on a sunshiny day in April. Entering the doorway of the brownstone where my then wife lived, I sidled sideways to let a janitor pass carrying a huge bin of trash.

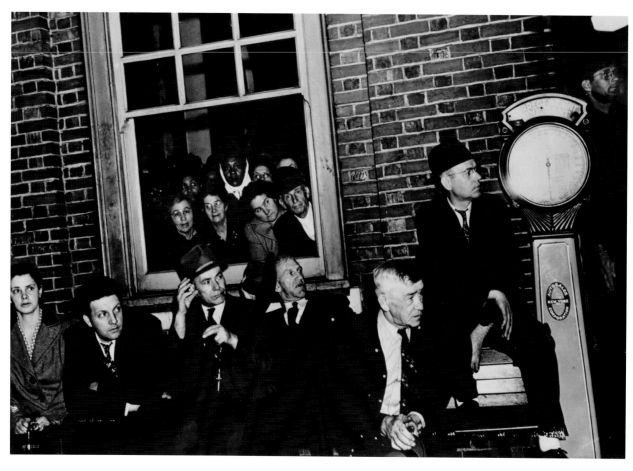

His black cheeks were wet. He sobbed.

W*hat's wrong?* I asked. He slowly let down the bin of trash, on my foot. *Ain't you heard? The President's dead.*

My nearly last assignment in the Army was to go photograph FDR's funeral train as it passed, of all places, through Chester, Pennsylvania. I wished they'd sent me to Washington.

I went to Chester and photographed some of the people—talking softly in the streets, families listening to radios at home, crowds waiting patiently at the depot that night for the slow funeral train. I recorded the look of loss and respect on their faces. ▲

Abraham Lincoln's slow funeral train, burning wood instead of coal, passed through that same station 80 years earlier . . .

93

AUGUST 6, 1945

The children in the school playground heard the plane and paused to admire its silver beauty shining in the sun. In one shuddering moment almost all of them were dead . . .

SURVIVOR Hiroshima

Thirty-seven years later, 1982, I met and talked with a survivor of that playground, Akihiro Takahashi, somehow grown to manhood. He'd become director of the beautiful and serene Hiroshima Peace Park and Museum.

My clothes were shredded, he recalled. *The skin came off my back, my head, it dangled from my arms. Pieces of glass were driven into me. When I looked around I could see very far because the whole city was gone. I made my way to the river. I saw many people with far worse injuries—a woman with her eyes popped, a mother and baby with all their skin gone . . .*

Like other *hibakusha* (bomb-affected persons), Takahashi welcomed his American guest with warmth and friendship. His life since childhood had involved frequent hospitalizations (for burns, liver problems, hands) and he was currently undergoing daily intravenous infusions. But Takahashi was an alert, multilingual, hardworking, modern man. He'd come through fire and seemed cleansed of racism, anger and self-pity.

It was our Japanese leaders who led us into the war, he said, *and the scientists who recommended the manufacture of atomic bombs— and President Truman and others who decided to drop the bomb. But the leaders are not the people. I hold no anger now. I know that hatred cannot bring peace to me, or to the world.* ▲

About 74,000 men, women and children died outright under the Hiroshima bomb. 100,000 died two days later from the second bomb, at Nagasaki. In 1982, 367,000 crippled *hibakusha* were still alive, under medical supervision.

BIRD IN YOUNG WILLOW TREE Hiroshima

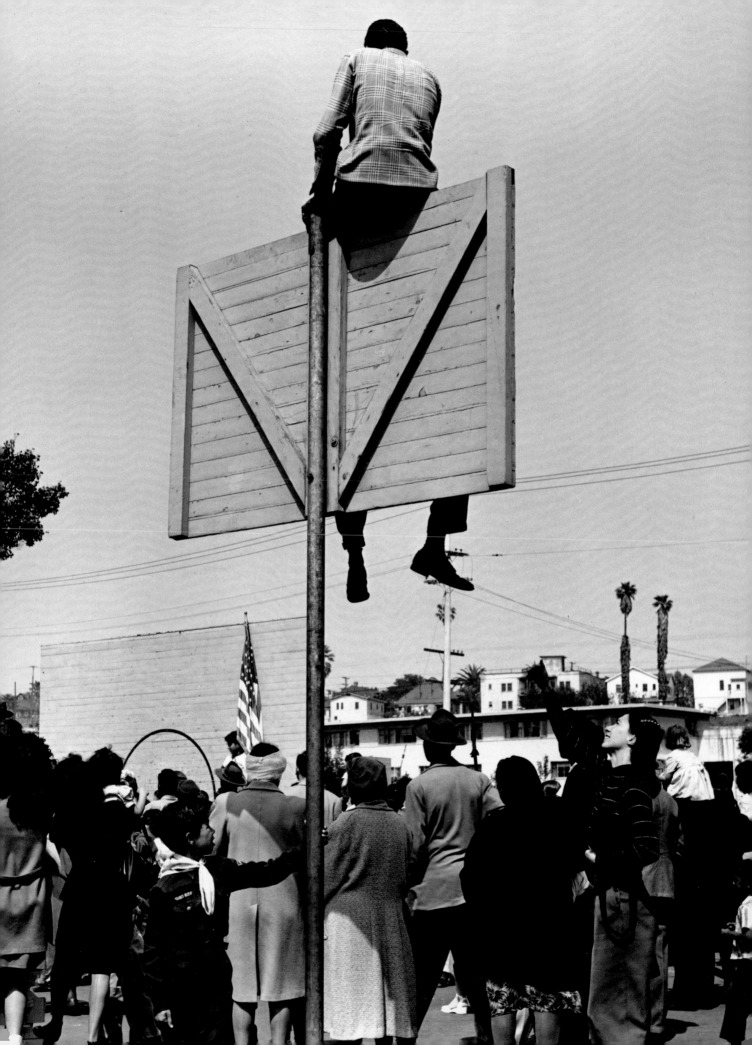

I DID IT MY WAY . . .

Frank Sinatra

three

LATER

FOURTH OF JULY Los Angeles

WAR WIDOW

Los Angeles. 1947. Mrs. Victor Guinness. The picture on the table is a drawing from an old photograph of Captain Victor Guinness, US Marine Corps.

The sash and medal around his neck are America's highest decoration.

The Congressional Medal of Honor.

Posthumous. ▲

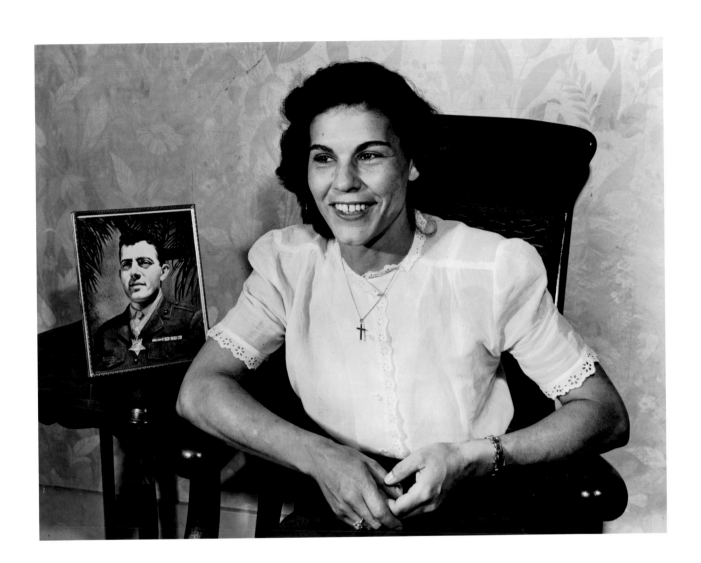

OH, FRANKIE!

He had gone the way of many Sicilian-Americans of my childhood: from feisty to churly, from leftist to rightist, from catlike to doglike . . .

Michael Ventura
LA Weekly

The teenage bobbysoxers back in 1942 who screamed and fainted in the aisles during Frank Sinatra's first concerts at the Paramount Theater are elderly ladies now with perhaps blue-tinted hair and a touch of stiffness in their joints. But they still go to Ol' Blue Eyes' concerts and buy his CDs and tapes. Remarkably, lots of modern kids like his music too. Sinatra lives!

In his 76th year, certainly not in need of money, Sinatra brings his paunchy body up there to the microphone and the lights—and by sheer chutzpah and musical mastery continues to transmute sentimental, sometimes egotistical, love songs into magic.

There's a darker side to this American success story—deceit, semi-literacy, attempted suicide, abuse of women, betrayal of friends, violence (beating up a journalist while Frankie's bodyguards held the man's arms so he couldn't fight back), and questionable involvement with Las Vegas gambling casinos and the mafia.

Francis Albert Sinatra was born 1915 across the river from Manhattan in Hoboken, New Jersey. He was the only child of Marty Sinatra, an unsuccessful professional boxer who never learned to read, and Natalie (Dolly) Garavante, from Genoa, an ambitious energetic lady who ran her household and her neighborhood and got her son his first show-biz booking—a singing spot on Major Bowes' radio amateur hour. According to Kitty Kelley, Frank's decidedly unauthorized biographer, the Sinatras were a criminal family. His father Marty, she reveals, was charged with receiving stolen goods. His uncle Gus was repeatedly arrested for running numbers. His other uncle, Babe, went to prison for participating in a murder. And his mother Dolly, who mainly supported the family working as a midwife, was in and out of court for performing illegal abortions *with a long wire . . . with special medication on the end of it.* Frank himself was arrested in 1938, and briefly jailed, on a morals charge involving a young married woman he proposed marriage to, got pregnant and deserted.

Politically, Sinatra seems to have been an opportunistic chameleon, changing his beliefs and friends to suit his professional and financial advantage. During the late 1940s he was getting bad press and few engagements because of his peccadillos with women and for escaping military service in World War II (he claimed a punctured ear drum). Suddenly, he picked up on the then popular post-war movement for civil rights and began singing benefits for liberal and radical organizations pressing for peace, disarmament and racial integration.

One of Sinatra's favorite songs at that time was *The House I Live In*, a patriotic ballad about the joy of being an American, *having the right to speak your mind out.* Music was

by Earl Robinson, lyrics by Albert Maltz. Maltz also wrote the screenplay for a Sinatra short film about Tolerance that won a 1945 Oscar. Frank and Maltz became warm friends and in 1946 he hired Maltz to write a feature screenplay in which Frank would star.

Boom! The Unamerican Activities Committee of the United States Congress, including a first term politician named Richard Nixon and chaired by Wisconsin congressman Joe McCarthy, descended upon the consciousness of the American people. It seemed it was *not* alright to speak your mind out. If Joe McCarthy and his committee disagreed you were likely to be blacklisted, lose your job and/or go to jail. Albert Maltz, who probably was a member of left-wing organizations, was called before the committee and refused to fink on his friends (*name names,* they called it). He was sent to jail for a year, along with nine other distinguished and principled writers, directors, actors and producers. Sinatra cancelled friend Maltz's screenwriting contract, paid him off in full (on advice of his attorney), never apologized, and never spoke to him again.

Sinatra's loyalty to his gambling casino friends and the international mafia, however, was fierce and life-long. He was given ownership of a serious piece of the Las Vegas Sands. He buddied with Bugsy Siegel, Joe Fischeti (cousin of Al Capone), Albert Anastatia, Frank Costello, Lucky Luciano, Mickey Cohen, Joe Banano and

SINATRA PRESENTS *BROTHERHOOD AWARD* TO EAST LOS ANGELES HIGH SCHOOL STUDENTS

especially Sam Giancano, who was *capo di capi* of all the mafia rackets in Chicago. The Giancano connection proved especially valuable during John F. Kennedy's presidential campaign. Frank campaigned for JFK, raised mafia money for him and enlisted Giancano in the fight. Giancano controlled Chicago's first ward and several river wards—enough to make an historic difference. In a close race Kennedy carried Chicago, won Illinois by only 8,858 votes, and won his election to the presidency by less than 119,000 votes out of 68 million votes cast. Sam Giancano told his beauteous mistress Judith Campbell (she later revealed): *Listen, honey, if it wasn't for me your boyfriend wouldn't even be in the White House.*

What? Yes. Judith Campbell was for two years back-stairs White House lover to President Kennedy. *How come?* His buddy Frank Sinatra procured her for the president—after she walked out on Frank himself because she objected to group sex as too kinky . . . The president's relationship with Judith Campbell ended abruptly when FBI chief J. Edgar Hoover showed Kennedy transcribed telephone taps of Campbell's conversations with Giancano and suggested it wasn't fitting or wise for the president of the United States to be in bed with a mafia boss's mistress. Frank Sinatra's box score with famous women, mostly beautiful movie stars, probably exceeds that of his closest rival, Warren Beatty—if only because Frank is older and had more time.

Sinatra's documented extra-marital conquests include, amazingly, Mia Farrow,

Judy Garland, Marlene Dietrich, Liz Taylor, Kim Novak, Lauren Bacall, Natalie Wood, Anita Ekberg, Marilyn Monroe, Lana Turner, Gloria Vanderbilt, Shirley McClaine, Ava Gardner, etc. etc. Many of these women were one-night stands (Frank wasn't very nice in the mornings). Several relationships progressed through pregnancy, abortion and desertion.

Sinatra may have cared for Ava Gardner

the most. When she split, he slashed his wrists in an elevator in a suicide attempt. Ava had an abortion. *I hated Frankie so much,* she said, *I wanted that baby to go unborn.* Elizabeth Taylor got the same treatment when she found herself pregnant by Frank and wanted to marry him. He arranged for an abortion. Later, after Taylor had married and broken with Eddie Fisher, Sinatra gallantly announced during a Chicago concert: *You can ask Eddie Fisher. He'll tell you the whole goddam thing. She left him. But then she got fat anyway, so who cares? . . .*

What seems to be left of Sinatra these days is solidarity with his old Hollywood and mafia friends, the embrace of new friends like Spiro Agnew and Ronald and Nancy Reagan, and his indomitable will to sing to

and be admired by endless audiences. For President Reagan's inauguration he resurrected the stirring Robinson and Maltz ballad, *The House I Live In*. Reagan and Nancy listened, entranced, quite unaware of the song's significance or its authorship. Reagan later rewarded Sinatra, along with other dignitaries such as Jacques Yves Cousteau and (gulp!) Mother Teresa with the Presidential Medal of Freedom.

Much of the Sinatra saga was designed and sustained by public relations hype—the strategically timed benefit concerts, the much publicized contributions to popular causes and charities. This pattern of control began back at the beginning, the 1942 Paramount concerts when Sinatra's media manipulator George Evans hired twelve sexy bobbysoxers, paid them each five dollars to jump and scream and yell *Oh, Frankie! Oh, Frankie!* Two girls were coached how to faint dead away in the aisles. Others were taught to moan in chorus. To make sure the big theater would be full, Evans handed out freebies to hundreds of youngsters, mostly female. Result was a box-office and media triumph for Sinatra which, with ups and downs along the way, has continued for half a century. Even today the old man can stroll onto a Las Vegas stage with his signature glass of whisky in one hand and cigarette in the other, be sure of an admiring full house, and walk away with a fast hundred thou for a weekend's work.

He Did It His Way, His Way

Frank Sinatra gave a concert at Knickerbocker Arena in Albany, N.Y., last week, and many in the audience thought he was drunk. He forgot the lyrics to the songs he sang — although they were on a Teleprompter — and introduced members of the orchestra, his wife and his son two times each.

His publicist said that Sinatra had made the multiple introductions...

No way can *all* this have been the result of PR. Something *real* had to be there. And it was. Sinatra. The man. The voice. The body language. The braggadocio. The populist vulgarity. The sexuality. The phrasing. The held-in poor boy anger. The affirmation of social, financial and artistic conquest over his intellectual betters by a semi-literate 8th grade dropout. When were *you* a guest at the White House?

Sinatra twice retired from singing—twice returned. He sings now not for money or success. He sings now because he has to, like breathing, like heartbeat. He is without question, like Caruso, like John McCormack, the greatest popular singer of his generation—except his voice and power resound now across *three* generations. He tries every time somehow to *do it better*. Los Angeles Times music critic Robert Hilburn wrote after a recent concert: *If the voice is a little scantier on the top, like his hair, the years have given him some rich new low notes. My friend the piano player jumped in her seat at the Amphitheater when Sinatra reached down to a low E flat.*

That's not in his range! she whispered.

It is now. ▲

FRANK AND BOB

We used to pass time together at Joe Kinney's Bar and Grill after our Lehigh classes. That's Bob with the beer. You can see Frank's profile back at the bar.

Bob's pack of cigarettes dates this picture as before World War Two, which was when Lucky Strike changed its green package to white. Bob has come through the years just fine.

Frank's life is another story. He was brilliant, charming and accustomed to achievement. Had to be best at everything. His dad expected that. Not a rich kid, Frank joined a fraternity of mostly rich young men and was well liked. He bought himself a new Ford on time. He was so active in extracurricular activities (lacrosse, flying club, chess, literary magazine) that he went on academic probation—which was soon fixed by hard work and a man-to-man chat with the dean. With women, Frank was a courtly killer.

Everybody lost touch during the war. In the middle '50s I was delighted one day to hear Frank's voice on the phone. *We're living in Santa Barbara*, he said. *You've got to meet the family. Come up for dinner.*

Dora was a lovely and resourceful woman. Their four children were well-spoken and self-reliant. Frank proudly showed me the nearly finished swimming pool they'd all been building together, mixing the mortar, laying the tiles. Frank's priorities seemed to have changed. He was less driven. He was doing well in marketing. In the war

he'd been a Navy pilot in the Pacific, decorated of course. *Guess what?* Frank said, as he poured me a glass of sherry. *I've joined Alcoholics Anonymous. Had some trouble with liquor and just quit. Been off almost six months.* At dinner Frank said grace.

A few weeks later Dora phoned. *Listen, Lou*, she said, *Frank's, well, gone. I'd like to ask you to be a pallbearer.*

We buried Frank on a golden morning in a green military cemetery overlooking blue San Diego Bay. A uniformed honor guard fired over the body.

What happened was Frank had backslid, been arrested for drunk driving. Third offense. *He couldn't stand the shame*, Dora said. *He couldn't do his job without a driver's license. Maybe he figured he just couldn't lick liquor. Maybe it was post combat stress. He was a proud man. Frank went out to the garage and hung himself.* ▲

He wasn't a constant winner in life like Frank Sinatra or Mohammed Ali. He was more like a tragic hero in Greek drama, a noble king brought low by some *fatal flaw.*

With the Greeks it was usually pride. Where Paul Robeson went wrong was being black too soon. Thirty years later he could have owned the Metropolitan Opera Company, or been President maybe, or at least mayor of Los Angeles or New York, or become the greatest movie-TV-recording-concert-political-sports personality in the history of showbiz.

What a property! All-American football star at Rutgers. Plus a dozen other varsity letters including basketball and track. *And a Phi Beta Kappa key.* Named by Walter Camp *the greatest defensive end that ever trod a gridiron.*

So he turned pro, right? No. He went to Columbia and earned a law degree. Then he married his sweetheart Essie, a chemist. And became an instant great actor, with the famous Provincetown Players and young Eugene O'Neill. Wowed London opposite Sybil Thorndike. Became a movie star. Developed one of the great bass-baritone voices of all time. *The Emperor Jones. Porgy. Showboat.* Photographed by Steichen for Vogue in role of *Othello.*

Paul Robeson was born in Princeton, New Jersey in 1898, son of an escaped slave. In his prime he was 6 feet 3 inches and 240 pounds of black talent, class and power. Nobody liked Paul Robeson. But he wouldn't accept racism. Figured blacks should be able to eat in any restaurant, attend any school, and vote. He spoke and sang for freedom, equality under law. Went to the Soviet Union and praised it as a non-racist society. Accepted a Soviet medal, The Order of Lenin.

In 1950 Robeson's passport was revoked (ending his concert successes in Europe and Africa) because he refused to state he was not a communist. Robeson probably never joined the Communist Party, but considered it a violation of his constitutional rights to be required to say so. A Supreme Court ruling later affirmed he was right and restored his passport. But that was *eight years* later.

Those were the days of the devious liar Congressman Joe McCarthy whose anti-communist campaign held the U.S. government and its people in thrall (*I hold in my hand a list of 51 card-carrying communists in the U.S. State Department.* McCarthy never found *one* communist in the State Department. But artists, writers, religious and labor leaders, scientists, educators, black organizations, government officials and many ordinary citizens were routinely spied on, impoverished and terrorized during this dark time. The Un-American Activities Committee did succeed in deporting, of all people, Charlie Chaplin (back to England) and did manage to jail, briefly, ten obstinate honorable Hollywood film-makers.

Co-conspirators who got their political

PAUL ROBESON SINGS IN CELLAR OF A CHURCH.　　Los Angeles

start working with McCarthy included such characters as the corrupt attorney Roy Cohen, a two-faced California congressman named Richard Nixon, and the handsome young movie actor Ronald Reagan who, as president of the Screen Actors' Guild, betrayed his own members by secretly providing Hollywood producers with a blacklist of supposedly radical actors, rendering them unemployable.

During these years the FBI regularly tapped Paul Robeson's phone, followed him in their cars and bugged the apartments of his friends. Robeson never recovered from this stress, either professionally or emotionally. He spent several years in and out of a sanitarium, died during the bicentennial year of the United States of America, 1976, in Philadelphia, where the Declaration of Independence was signed. ▲

BART VAN DER SCHELLING SINGS . Los Angeles

ONE INDIVIDUAL, AND HISTORY

Half a century ago the world had the chance to stop a ruthless aggressor and missed it. I pledge to you we will not make that mistake again.
George Bush 1990

Bart van der Schelling, a naturalized U.S. citizen born in Amsterdam in 1909, was a folk singer, a painter, a soldier and by trade a skilled tool maker. A gentle man with an endearing lyric voice, he was loved by many friends, and by his wife Edna.

In 1937 he went by ship to Spain as a volunteer in the Abraham Lincoln Brigade, which fought almost three years in defence of the Spanish republic.

History moves fast. By the 1930s Spain had emerged from centuries of royal and military dictatorships and had an elected democratic government with a constitution based on the American example.

But the Spanish military, together with great absentee landowners and a still-medieval church that monopolized religion, education and law, wouldnot accept democracy. In July, 1936, Spanish garrisons mutinied over all Spain, led by General Francisco Franco who brought to the Spanish mainland African troops he commanded in Morocco.

The Spanish government no longer had an army. But it did enjoy the loyalty of most Spaniards. There was a rush to join the new people's militia. Spain looked for help to the League of Nations (predecessor of the United Nations) and to the world's great democracies.

No help came. The Spanish government was quickly labeled *communist*—which in part it was, though Spanish politics then embraced anarchists, trade unionists, Basque and Catalonian separatists, socialists, social democrats, non-party patriots and liberal, often Jesuit, catholics. The United States, England and France quickly organized an international blockade of Spanish ports which forbade entry of weapons, oil, even food and medical supplies—to both sides. But this blockade was enforced only against the legal government. Nazi Germany freely delivered weapons, munitions and aircraft to the rebel forces. Fascist Italy landed tanks and thousands of its own troops on Spanish soil.

For Hitler and Mussolini the Spanish Civil War was a rehearsal for World War Two. The Germans invented carpet bombing in Spain, sending flight after flight of its bombers over the defenseless city of Guernica. The Italian fascists learned in Spain how to use their tanks.

Hindsight is easy. It would seem now that if the western democracies had drawn the line against fascist aggression in Spain (or in Ethiopia), World War Two might never have happened. *Fifty million lives might have been saved.* Even the murderous paranoia of the Soviet Union's Josef Stalin might have been mollified. *Glasnost* and

peristroika just perhaps maybe might have started to happen fifty years earlier!

Generalisimo Francisco Franco's conversion of the Spanish republic into a fascist dictatorship was complete by early 1939. This was followed by British Prime Minister Neville Chamberlin's signing of the Munich Pact with Adolf Hitler (*Peace In Our Time,* he called it). Quickly then, Hitler moved into the Sudetenland coal fields, Czechoslavakia, and Poland. World War Two had begun.

What was left of the Abraham Lincoln Brigade returned home. Soon their able-bodied survivors (casualties in Spain had been about 40%) were volunteering again—for service in the United States armed forces and merchant marine. Many Brigade vets died or were wounded in World War Two. Many were decorated for heroism.

Franco's fascist dictatorship managed to hold power over Spain until after World War Two, when it was replaced by a popular uprising and an elected democratic government. Veterans of the Abraham Lincoln Brigade were invited to visit Madrid as honored guests.

And van der Schelling? He survived fierce battles but near the end was dropped by fascist artillery. He returned home crippled, for the rest of his life wore a metal and leather brace on his neck and spine.

During the late 1940s and early 50s van der Schelling sang with Paul Robeson to raise money for Spanish civilian refugees living in France and for surviving members of the Lincoln Brigade who needed medical care and family support.

Bart van der Schelling was only 50 when he died, in 1959, in Los Angeles. ▲

VAN DER SCHELLING SINGS WITH ROBESON
Los Angeles

MASTER

For almost 30 years after his retirement as head of the montage department at MGM, Slavko Vorkapich taught the art of film to young filmmakers. From the beginning there was a small floating coterie of current and past students who wouldn't let go of the old man. One seldom gets close to genius.

We kept attending his lectures, thinking through his theories, screening our films for his austere appraisal.

In the short history of film, Slavko Vorkapich was perhaps its greatest teacher. He lectured in his own Coldwater Canyon living room, in small rented movie theaters on Saturday mornings, and, as professor, to overflow classes at USC, Princeton, the Museum of Modern Art NY, the University of Zagreb (Yugoslavia), the American Film Institute, and UCLA (where he was for two years Regents' Professor).

Director William Friedkin (*The Exorcist*) acknowledges debt to Vorkapich. So do Ed Spiegel (*The Hellstrom Chronicles*), Irvin Kershner (*Star Wars II*), producer Dan Selznick, filmmaker Willard Van Dyke, critic Jonas Mekas, Academy Award cinematographers Conrad Hall and Haskell Wexler, and a few thousand other film workers from Prague to Australia.

Vorkapich's power as teacher lay in his passion for movies and his singleminded life-long analysis of the psychology of visual perception.

Other teachers dealt with film history, literature and anecdotal gossip. They used PHD words like ontology, *auteur*, *mis en scene* and semeiology. Vorkapich talked about what objectively happened on the screen and what that could do to the mind, the heart and the gut. He demonstrated the effects and uses of dissolves, cuts, visual leaps, editorial rhythms and sound-image montage. He screened for us huge reels of scenes from famous movies and demonstrated how Welles, Griffith, Ford, Fellini and Coppola all made elementary mistakes. He taught that film was not photographed stageplay, not photographed literature, certainly not TV's talking heads.

Film, Vorkapich taught, is an art of light, movement and sound that dances through time. Such ideas made Vorkapich seem a priest of film. His clarity was in sync with the rebel young filmmakers of the 50s, 60s and early 70s. His classes were like church. There, beyond all the commercialism, we disciples alone were blessed with the wine of Truth, the wafer of Beauty and the organ music of How To Get It All On.

Vorky's principles worked. Out in the professional world his students got jobs. They could conceive and create film sequences that surprised the eye. But some questions arose. It turned out that making movies also involved creative work with actors, and with story. We found that flashy visuals alone are nice but not bankable. We learned that audiences really do

want photographed literature and famous faces talking.

From the beginning the master's band of loyalists had pressed him to finish writing his Book. It would confound the Philistines, be the Bible of film art. But the master was stubborn. He said he had further researches to complete first. A few years later he said what was needed was not a book but a film about film. We raised foundation grants of $25,000 (and free studio, equipment and crew). Well, he explained then, the project really required a series of films, at least ten hours screen time. How much money? Oh, he couldn't commit himself to a limit. *Maybe $250,000, maybe more. How much did Sir Kenneth Clarke's TV series Civilization cost*?

We Vorkapichian loyalists shuddered, labored some more because we loved him, and brought forth a conglomerate grant of such complexity and size as to amaze. There would be ten hours of film. Contributors of money and facilities would include Harvard, MIT, NEA, MOMA, AFI, the Academy of Motion Picture Arts & Sciences, UCLA, and the Goldwyn Foundation. Conditions of the grant were that a finite production budget be prepared and a supervising producer of competence be brought in to relieve Vorky of managerial chores (and keep him from over-spending).

OK, the master said, finally pleased. The supervising producer, whose name and impressive production credits Vorkapich had approved, flew in from New York to meet the master. She wore pants, high leather boots, massive jingling gold jewelry and reddish frizzled-out hair. She talked fast. *I can't work with her*, the master said. *I'm going to Spain.* And he did. ▲

SLAVKO VORKAPICH. Born in Serbia (later Yugoslavia), 1899. Died Mijas, Spain, 1977. Naturalized US citizen, painter, film artist, teacher. Considered by some the foremost theoretician of motion pictures since the death of Sergei Eisenstein. Designed and directed memorable screen passages such as the Furies sequence in Ben Hecht's *Crime Without Passion* (1934), and at MGM, invasion of the locusts in *The Good Earth* (1937) and battle sequences in the Ingrid Bergman *Joan of Arc* (1948). Made, with collaborators, four short films of his own and, in Yugoslavia, one feature-length drama, *Gypsies* (1956), which was re-edited by the Yugoslavs and never exported. Married for 36 years to Denise Sentous. Survived by daughter Mira, anthropologist, and son Edward, cinematographer. Published several short articles on film theory, the first in 1930, but never completed his long-awaited book.

A JOYOUS WAY OF BEING

Alicia lived in a 19th century stone castle in East Los Angeles, a Catholic orphanage. It was a huge Federico Fellini sort of place. Girls here, boys in the other wing. Ghosts, doubtless, in the echoing hallways. Light-hearted nuns glided through high doors, their medieval starched headpieces airborne, preening their wards for the visiting photographer.

Alicia spoke mostly Spanish. I photographed her and her thirty or forty friends polishing shoes, reading, skipping rope, righteously brushing teeth. Somehow my camera kept coming back to Alicia. The light seemed always better where she was.

I didn't realize till later that I'd fallen in love with this child, and the woman she would become. More than that, Alicia had become my teacher.

This is not a figure of speech. Alicia had given me a lalapaloosa of a smile and let me photograph it. She smiled. In joy. With her whole heart.

The power wasn't just in her youth (we know wholeheartedness in old people too). I doubt it came from formal religious understanding (though Alicia was dutifully learning her catechism). It wasn't just the camera. (I watched her play, unphotographed, with her friends and the Sisters, noted how she warmed and elevated everybody).

This was a special light-emitting little girl. She beamed out a radiance that was com-pletely trusting, without calculation or judgments. She set an example of utter good will toward which I can only aspire. For I, perhaps like you, am a grown urban modern, with cares, and ambitions, and too much thought, and too little light (perhaps that's why I collect light on bits of paper).

Here is Alicia's photograph, talisman brought back from her high country. A paper icon remindful of her actual spirit, heart and heat. It proves to me, when I doubt, that there can be such a joyous way of being. ▲

118

THE SHOOTING AT CAMP OBOLER

The very excitable Mr. Arch Oboler, who can floor a co–worker with a roundhouse as aptly as his writing can leave an audience stunned, has just completed the first motion picture about the atomic age.
Louella Parsons

During the 1930s and 40s he was almost King of Radio (topped only by Norman Corwin). A small street-wise Chicago kid, Arch Oboler sold his first story at age 10, became a near-champion Golden Gloves boxer, wrote, directed and produced more than 700 radio plays. His best remembered production was the spooky after-midnight series *Lights Out*.

All the great stage and movie stars of his time worked, for radio, under Oboler's direction—Betty Davis, Raymond Massey, Humphrey Bogart, Charles Laughton, Katherine Hepburn, Boris Karloff, Olivia de Haviland, Ingrid Bergman, Mae West, Marlene Dietrich, Joan Crawford, Burgess Meredith, Bob Hope and many others. When later Oboler moved west to make movies he commissioned the legendary architect Frank Lloyd Wright to build him an elegant home in the Santa Monica mountains.

But by 1949 story-telling radio was dying, television was starting to encapsulate the American consciousness and Arch Oboler was not bankable in Hollywood. Just returned from an expensive, failed, film shoot among the Masai tribe in Africa, Oboler was nearly broke.

BLACK SCREEN. FADE INTO FILM EDITING ROOM, HOLLYWOOD. FOUR YOUNG MEN IN SHIRT-SLEEVES HUDDLE OVER A MOVIEOLA. Light in room darkens. The young men look up.

CUT TO FULL SHOT COMPACT FIGURE OF MAN ENTERS IN SUNSHINE LIGHT THROUGH OPEN DOOR. In his early 40s, he wears sneakers, jeans, sweatshirt, glasses, baseball cap and a smile.

ARCH OBOLER
Hi! I'm working next door. Thought I'd say hello. I'm Arch Oboler.

We were dazzled. Oboler was charming, famous, boyishly modest. And he seemed interested in *us*, four would-be filmmakers just out of USC film school. We showed him the rough cut of our collaborative short film. Later, at Oboler's request we read and critiqued *Five*, a feature screen-play he'd just finished about five survivors of an atomic war. We told him his script was fresh—but much too talky, it didn't *move*. We were uppity kids. But Oboler smiled, and listened well.

Two weeks later, lightening struck. Oboler came by and offered us the world. He was going to produce and direct *Five*, he said, shoot it with only five actors up in the barren Santa Monica mountains around his home, and use no studio sets or union crews. The film was to be made cheaply but with production qualities

equal to multi-million dollar studio movies. We together would surprise the Industry with what young independent talent could achieve. Art Swerdloff (our most theoretical and outspoken member) would work as assistant director. Ed Spiegel would be film editor and gaffer/grip. Sid Lubow would be operative cameraman. And I would be director of photography. We would each be paid $135 a week—plus a piece of the profits. Was it a deal?

So began the initiation of four innocent young filmmakers into the business, artistic and, yes, sexual realities of the Hollywood film scene.

To make a long story a bit shorter, *Five* did get finished, on an astounding budget of $72,000. Nobody died. Columbia distributed. The reviews were good. *Five* came in number 49 on Variety's annual list of the top 50 money-earning movies of 1950. Oboler's vision came true.

But by the end of production, *nobody felt good* . We'd lived, cast and crew, for uncountable summer weeks in hot army tents pitched amid desolate rocks. We ate Mrs. Oboler's lukewarm penny-pinched meals. Those of us with military experience recognized the scene—it was boot camp all over, Oboler our hated Sergeant.

Arch Oboler was older, tougher physically and harder working than any of us. He earned our grudging respect. Problem was his gift for creating exciting radio drama did not transfer well to a visual medium. His screenplay was all spoken words. His direction was stagebound, soundbound. He surprised us by admitting this. *That's why I hired you boys,* he said.

One evening early in the shooting, as we were falling down tired on our army cots, Oboler entered our tent . *You know,* he said, without preliminaries, *Jerry is my girl.* We didn't know. Jerry was Oboler's secretary, also script girl on our production. She was a beautiful young woman, two or three inches taller than Oboler, and a subject of speculation among our crew. One of the guys had indeed made moves in her direction, so far unsuccessfully. *What about your wife?* somebody asked. Oboler smiled at our innocence. *Jerry's been my girl for years now,* he said. *We all live together, Jerry and Eleanor and I. Jerry and Eleanor are best friends.* Startled and perhaps titillated by Oboler's straightforwardness, we all agreed to back off.

Another, less friendly, meeting occurred, again in the crew tent, on our own time, when Oboler felt it necessary to explain one of his basic directorial techniques. *I always sleep with my leading ladies,* he told us. *A director,* he continued, *has to know his actress intimately. When director and actress collaborate on this deep level, then a great performance becomes possible.*

Five's leading (and only) lady was Susan Douglas who had been flown in from New York. A boyish, energetic girl with a mobile sculptured face topped by straw-

blond hair, she was simple, unaffected, charming. On camera she came instantly and powerfully into character. Susan did not live in a tent like our crew and her four actor colleagues. As befit her status (and apparently for his own purpose) Oboler had given her sole use of Frank Lloyd Wright's magnificent afterthought, the one-bedroom Cliff House perched atop a rocky ridge about a quarter mile from the Big

WILLIAM PHIPPS AND SUSAN DOUGLAS IN SCENE FROM *FIVE*

House. Susan had several times invited our crew there, and once her fellow actors, for late afternoon conversation and tea. Now Oboler let us know it wasn't protocol for crew to mix with the lead actress. Anyway, like Jerry, Susan was strictly *his* turf. With equal straightforwardness we told the boss we didn't see it that way— and wouldn't comply. When we told Susan of our meeting she thanked us, and wasn't surprised. Thereafter, there always seemed to be a crew member or two sort of guarding Susan Douglas. Weekends off, she and the whole crew zipped down to Los Angeles, where she was often house guest of Ed and his wife (*not* as a *menage a trois*).

The growing fury of our horny director did not seem to interfere with the quality of his, or anybody's, film work. Each noon's screening of scenes shot the previous day (motored up from our Hollywood lab) looked better and better.

The way the shit finally hit the fan was as follows. One hot afternoon camera operator Sid Lubow dropped the lens filter I'd specified for a special dark sky effect (we were shooting in black and white). The three-inch square of red glass broke to bits on Frank Lloyd Wright's flagstones. When Oboler learned we had no spare filter he blew up at Sid. Whereupon Art contributed a cheerful, *Those things happen, Arch, can't be helped.* To which Sid added, *I'll get perfect the day Oboler doesn't make any more mistakes.*

Lack of respect for the director in presence of his actors is normally subject to court martial by the paymaster. This time, however, the purpling Oboler mumbled he needed *to cool off* and stomped from the set to a rock ledge below the Cliff House, breathing hard. I had turned my back to the set and was rigging a substitute arrangement of two sandwiched gelatine filters to the camera when Oboler returned. There was a line or two of quiet talk, then suddenly—a great scuffling, guttural curses and a quick sound-image montage of fists and bodies, of two pairs of eyeglasses tinkling to the terrace, of Miss Douglas and script girl Jerry screaming bloody murder, of real blood spattering over Art's white shirt, of big Ed piling onto Art's back and I onto Oboler's, Ed and I pulling the gladiators apart.

Art's broken glasses had made bleeding cuts around his left eye. Oboler was unmarked, though pop-eyed and half-blind without his thick lenses. According to Art, Oboler hit him first, without provocation. According to Oboler, Art *laid hands* on him, whereupon he whopped Art with a body blow, Art hit him in the face and broke his glasses, and Oboler smacked Art in the face and broke his glasses . . . Nobody noticed me. I was a groggy peacemaker, having taken somebody's fierce last punch alongside my head.

Sid drove off with Art to a doctor. Ed, Susan and I cut out for L.A.—following a tense scene at Camp Oboler's locked-from-

the-inside gate where Oboler reminded Douglas of her contractual obligations (*You'll never work again in this business!*). Next day Art filed a $30,000 civil suit against Oboler. The shooting at Camp Oboler was o–v–e–r.

But only three days later, Douglas had dried her tears, Oboler had written a conciliatory letter, and Swerdloff, patched and sobered, had dropped his law suit. The lure of fame, art, gold and perhaps loyalty to each other proved too compelling for any of us to resist. A chastened crew and leading lady again trekked the mountain roads to Camp Oboler.

What had been a bad enough boot camp now became a universal ulcer factory. Aggrieved parties didn't speak to each other except in line of work. Under the dinner tent each evening our crew and Susan sat at one end of the long table, the four male actors (who had remained Oboler loyalists) occupied the other. Oboler sat in the middle. Communication between the two clans was confined to civilities like *Would you please pass the chicken?*

Yet on the set each day movie miracles seemed to happen. William Phipps, the bearded handsome male lead, though he now thought Susan Douglas was a jerk, achieved powerful emotional scenes with her. Smooth James Anderson created a convincing, glint-eyed villain. Old Earl Lee was exactly right as the doddering

ex-bank clerk. And black James Lampkin (a jazz artist and Julliard graduate) actually drew applause from cast, crew *and* Oboler following his close-up performance of a particularly effective scene.

Susan Douglas, unforgiving, continued to perform brilliantly on camera, nevertheless needling Oboler with sour faces at direction of which she disapproved, and by carrying a wad of chewing gum in her

ARCH OBOLER HOLDS END-SLATE, SUSAN DOUGLAS HOLDS BABY.

mouth which she would immediately masticate when Oboler called *cut*. This tactic was double-edged because it showed up when we screened the daily rushes. After Oboler called *cut*, a few feet of film always passed through the camera, revealing Susan's screen character of Roseanne transforming into a bored schoolgirl chomping her cud, looking off-screen with cow eyes. And there was more . . .

One Monday morning a totally exasperated Oboler waited from the 8AM call till noon for arrival from a weekend in Los Angeles of two missing crew members— and his leading lady. There were apolo-

124

gies. Susan had been *car sick*. But a couple of days and similar incidents later it became apparent that what she had was *morning sickness*. Miss Douglas was pregnant.

For Oboler, this was the last traitorous straw. He mumbled darkly about pregnancy being violation of contract. But Susan continued to work hard, and well—except for an occasional whoozy-faced morning. Oboler, in a careless moment, called her *a great intuitive actress*. In off hours, Susan concentrated now on long letters to her husband back in New York.

There was a nifty irony in all this. Oboler had chosen to shoot *Five* page by page, in screenplay chronology, and as we now neared the final scenes, Susan's character Roseanne became pregnant. This was Oboler's thematic punchline—that with everybody else in our world dead from atomic war except four men and one woman, she might be the Eve who could begin the birthing of a new human race.

To this end, Miss Douglas was required to wear under her dress a pregnancy balloon that was blown up a little larger each shooting day, until finally, under Arch Oboler's direction, she was delivered of her screen baby—and was free to return to her husband and deliver a real one.

Postproduction editing, sound mix and musical scoring of *Five* were still another bucket of worms. The irrepressible Art Swerdloff, after another argument (short of fisticuffs), finally got fired. Sid and Ed also left, leaving me as sole crew survivor. The distinguished editor-director John Hoffman (who just happened to have been side-kick to Slavko Vorkapich at MGM) was brought in to finish film editing.

The final lesson about filmmaking we four apprentices learned from Oboler was how none of us ever saw a penny of promised profits from *Five*. As is Hollywood's custom, the money somehow evaporated through creative bookkeeping by the producer (Oboler) and the distributor (Columbia). Remember—prints, advertising, overhead, women, lawyers and limos cost lots of money. ▲

Arch Oboler was a master of radio drama, a bold film showman, and an important technical innovator. He was first to produce a three-dimensional (with glasses) feature motion picture—*Bwana Devil*, in 1952. He was first (for a film called *Five*) to use magnetic tape for motion picture sound recording, making the traditional and lengthy process of recording sound on film instantly obsolete.

Arch Oboler died in Los Angeles in 1987, survived by his wife Eleanor and three sons. A fourth son had died tragically in a Frank Lloyd Wright swimming pool high in the Santa Monica mountains.

MORE CLEARLY THAN THE EYE ITSELF COULD SEE

He couldn't smile anymore. Approaching 70, the most influential photographer of his time had lost control of his facial muscles. Parkinson's disease. He couldn't laugh anymore or look surprised or properly cry. He'd lost the free use of his hands. His walk had become the classic Parkinsonian shuffle.

But his eyes were still Edward Weston's, full of speculation and wonder, burning from the prison of his body like the eyes of a caged hawk.

His was the vision that had freshly discovered the human face, the machine, the nude in sunlight, the American landscape, the cosmic size of little vegetables. He'd been one of the most productive artists ever, in any medium. His influence was profound on Willard Van Dyke, Imogen Cunningham, Wyn Bullock, Ruth Bernhard, his own photographer sons Brett and Cole, and his hundreds of other sons and daughters who saw his pictures and books or made pilgrimage to his always open door on the California coast near Carmel. Ansel Adams was his neighbor, admirer and close friend. This photograph, with Brett, is a blowup from a single frame in my 1956 film about photography and Edward Weston, *The Naked Eye*.

Weston's personal life was bohemian and romantic. He was lover of most of his many figure models. After marriage in 1909 to Flora Chandler, after building a successful photographic business, after fathering four boys, he did a Gauguin and ran off to Mexico with young movie starlet Tina Modotti. Mexico was three years of startling massive work. Friendship with painters Rivera, Orozco and other firebrands of the Mexican revolution. Tina Modotti became a sensitive photographer, and a Marxist, and left him (or he her?).

E.W. was the first Guggenheim fellow in photography. At 53, after Flora had died, he married again, 19-year-old Charis Wilson, model for his nudes on the dunes of Oceano. That marriage lasted ten years. He was widely published, internationally exhibited. The Museum of Modern Art censored out one of his frontal nudes from its 1946 Weston retrospective.

In his last years E.W. couldn't photograph or print. But he continued to show his work to young visitors, and to view theirs. Speaking with difficulty, humility and precision, he taught the hows and the worthwhileness of work, as the earlier master Alfred Steiglitz had done for him in New York back in 1922.

Like Picasso, Edward Weston was surrounded throughout his life by artists and love. Sons Brett and Cole took turns giving years to his care, cooking, shopping, massaging the old body, printing the negatives under his supervision. Edward's carpenter son Neil built the little redwood studio house for him. First wife Flora, a schoolteacher, gave money when he needed it (with amazing selflessness she'd helped finance the original breakaway to Mexico with Tina). Second wife

WESTON CRITIQUES PRINTING OF HIS NEGATIVES BY BRETT. Carmel, California
Movie still from *The Naked Eye.*

Charis, twenty years after his death, edited two books of his photographs, one of them the nudes.

There were always famous parties: sons, in-laws, grandchildren, old lovers, old photographic pals, publishers, patrons, restauranteurs, musicians, writers, intense young people with portfolios, all come to talk, look at photographs and be with Edward.

There's firstborn son Chandler up from Los Angeles, bearhugging Edward, kissing his bald pate. There are Ansel Adams, Jake Zeitlin, Imogene Cunningham, David McAlpin, Dick McGraw, Rosario Mazzeo, Robinson Jeffers, Ruth Bernhard and Henry Miller, laughing with him over a table of bread, cheese, peppers, wine and fruit. There a beautiful daughter-in-law shows him the new grandchild.

Edward Weston died quietly in a chair in his cabin in Carmel the first morning of 1958. In his diary he had written: *What I tried to do my life long was to reveal the world around us . . . to reveal in photographs the form and meaning of things more clearly than the eye itself could see.* ▲

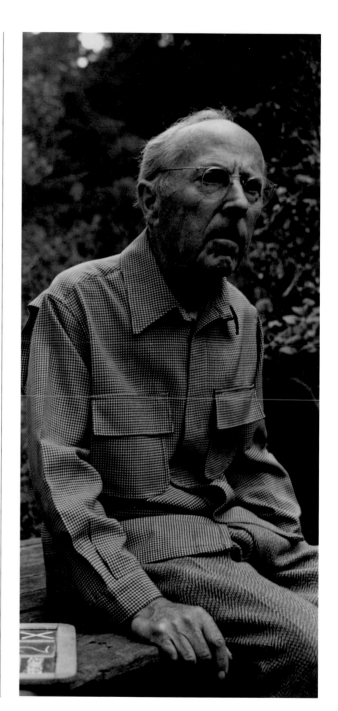

MARLENE'S OSCAR

Someday someone will write a startling, full and true biography of Marlene Dietrich. There's no way I can do that here. Nor do the 273 pages of her recent autobiography *Marlene* tell us much. This magnificent artist is jealous of her privacy. *Facts are unimportant,* she writes.

Age, for instance, which is not mentioned in her writings. Incredibly, Dietrich is almost as old as our century. Daughter of a Wehrmacht officer who died in the first world war, she was born in Berlin in 1901.

About love, she writes: *The relations I've had with different great men may be difficult to understand, and I don't intend to explain them. Tough luck if you haven't understood. If you're only interested in physical love, then you can immediately close this book . . .*

Sure. Except that following two charming and lyric chapters about her childhood and young womanhood, M.D.'s autobiography consists almost entirely of suggestive incomplete accounts of her relationships with famous and powerful people. Of Joseph von Sternberg, who directed her in the German production of The Blue Angel and then brought her to Hollywood, she writes: *Nothing is more pleasant than to know what's expected of you in life, in work and in love . . . he created me.* Of Charlie Chaplin: *We became friends when he was in the middle of one of his many divorce suits, and we spent many evenings together.* Ernest Hemingway: *I loved him from the very first evening.* Jean Gabin: *The ideal all women seek . . . but he was stubborn, extremely possessive and jealous. I liked all these quali-*

ties about him.

Elizabeth Bergner: *She was an impressive phenomenon, neither man nor woman.* Alberto Giacometti: *I didn't turn away from his love.* Spencer Tracy: *With just a look or a single word he could mortally wound me. I loved him for this reason, and because he knew how to command.* Edith Piaf: *She liked me, perhaps she loved me. But I believe she could only love men.* General George Patton: *He lifts me like a feather, and has me brought to my quarters in his command car . . . I still have the revolver he gave me.* Richard Burton: *The perfect seducer, . . . I met him when he was deeply in love with another woman so there was nothing I could do.* Orson Welles: *He offered me his house. I settled down in it. We spent most of our time in the studio in front of a microphone.* Billy Wilder: *When she was in Hollywood she always lived with me.* Aristotle Onassis: *Unlike most rich people he wasn't boring.* Frank Sinatra: *. . . a very charming man.* Rudolph Nureyev: *I often saw Nureyev in London because we were neighbors.* Mikail Barishnikov: *He had beautiful long legs and the face of a young God.* Jack Kennedy: *One evening Jack Kennedy invited me to dance. I loved all the Kennedy children, and this love has never ceased.*

A naturalized American citizen, M.D. entertained troops throughout the second world war and insisted on working up front with the combat soldiers. Asked once (by Billy Wilder) if she'd ever slept with Allied Commander Eisenhower, she replied: *How could I? He was never that close to the front lines.*

DIETRICH LIGHTS UP DURING BREAK IN RECORDING OF *BLACK FOX*. Everybody smoked those days.

About General Omar Bradley, M.D. writes: *All generals are lonely. The GIs can disappear into the bushes with a local girl. Not so the generals. Eyes follow every one of their movements. Never and nowhere can they kiss someone, or lay someone down on a haystack. They are hopelessly alone.* When Bradley was ready to lead the final drive of his troops onto German soil, he ordered M.D. for her safety to go to the rear and visit military hospitals. *I was dumbfounded*, she writes. *I spoke in angelic tones; I pleaded with him; I did everything conceivable to tug at his heartstrings . . . General Bradley finally allowed me to enter Germany.*

In a three-page tribute to herself that M.D. prints in her book, Kenneth Tynan writes: *She has sex but no particular gender. She is every man's mistress and mother, every woman's lover and aunt, and nobody's husband except Rudi's . . .*

Yes, there was a husband. Rudolph Sieber. He and Dietrich were married in 1924. Their only child Maria was born the following year. Dietrich tells us Rudi was *blond, tall and clever* and that she was *head over heels in love.* Sieber was casting director on Dietrich's first film (he gave her a bit part) and later traveled the world doing his *film work.* Whatever that was. As casting director? Agent? Producer? Director? Distributor? Dietrich doesn't say. She does report that when Hitler's government offered her husband the top job at UFA film studios (he was to bring back his wife from the U.S., of course), Sieber slipped out of Germany overnight, deserting their fine Berlin house and all its furnishings, and continued his work in France. There he was usually *detained by his professional commitments.* M.D. visited him in Paris *when he wasn't traveling in other countries.* Later, Sieber acquired a ranch in California.

My own experience of the cosmic force that is Dietrich occurred in 1952 when I was making *Black Fox*, an independent 90-minute documentary film about the rise and fall of Adolph Hitler. I'd written what I thought was a strong script, had developed camera and editing techniques that seemed innovative then, and had researched out many thousands of feet of historical and wartime film footage. Included were horrifying scenes of warfare and of the skeletal survivors of Hitler's concentration camps. To narrate my film I desperately wanted the sensibility and the German-accented voice of Marlene Dietrich. No one else would do.

But how to get her? I had no studio behind me. No distribution or grant commitment. Not even enough money to finish the picture. Through a friend of a friend who was a friend of Dietrich's I finally reached the great lady. Yes, the message came back, she would come to a screening of the 30 minutes of film I'd so far edited. The projection, in 35mm black and white, would be silent. There were no sound effects, no music, no voices. I myself (gulp!) was to read for Miss Dietrich the narration I'd earnestly written for her . . .

When the lights came up in the screening

NAZI SOLDIER EXECUTES WOMAN AND CHILD. Photo from government archives of Poland.
Movie still from *Black Fox*.

room, Dietrich looked at me, expressionless. There was at least ten seconds of silence. *Yes,* she said, *I'll do your narration.* I told her about the money. *Never mind,* she said, *that's not why I want to do this film.* We agreed on Screen Actors' Guild minimum, which was then $125 a day. Plus a small percentage of profits (if any). She ultimately accepted only three days pay, to make it legal with the Screen Actor's Guild.

Working with Marlene Dietrich was a joy. We collaborated in my cutting room at 1600 Broadway (in Manhattan) and at her book-lined apartment on Park Avenue. There were script conferences, screenings of new reels, rehearsals, and finally the recording sessions. M.D., I learned, is an absolute professional. She is five minutes early for *every* appointment. She puts on *no* famous-person airs. She works as long as it takes. She treats cabbies, assistants, secretaries, clerks and waiters with no less cordiality than she gives Important People. Unlike almost all actors and actresses, *Dietrich knows film.* She understands lighting, camerawork, writing, the editing process, and sound-image montage (her teachers, of course, were von Sternberg and Orson Welles).

M.D. gave her upstart director, me, complete respect and obedience, except when she disagreed—and she was often right. She reads voraciously, is fluent in several languages, and knows more history than almost anybody. She requires that everything be done right. During one recording session she had a line to read about the Spanish city of Guernica (leveled by Nazi bombers during the Spanish Civil War). *Is it pronounced Gernica or Gwernica?* she asked. I told her how I thought it should be. Neither of us was sure. Dietrich would not record the line until I had phoned the Spanish embassy, which confirmed that *Gwern*ica was correct.

Riding up in the film-building elevator with Dietrich one day I noticed a piece of bright lint on her white angora sweater. *Piece of fuzz,* I said, reaching to pick it off. She swung her shoulder away—and laughed. *That's my Legion of Honor,* she said. It was. Instead of wearing the red ribbon that is one of France's highest decorations, Dietrich chose to wear a single scarlet thread.

One morning around 3 AM—we'd been working late on script changes in her apartment—M.D. cooked me a breakfast of toast, tea and a pair of lovely, fluffy, somehow-spiced eggs that my nose, tongue, and heart have never forgotten.

Black Fox got rave reviews in Variety and The New York Times, a standing ovation and a First Prize at Venice Film Festival, and an Academy Award for Best Documentary Feature. It bombed at the box office, never earned back its spartan production cost ($90,000). Dietrich's name helped me raise completion money. But even Dietrich couldn't make moviegoers take their dates to see nations destroyed and living corpses in concentration camps.

* * *

Bathed in spotlights and applause, on national television, I raised my Oscar to the audience and told them it really belonged to Marlene Dietrich. It did. She made the film happen. Her voice transmuted my factual narration into poetry, fire and love. At film's end, as the camera flew low over the ruins of Berlin, her voice became a mournful song. *Götterdämmerung,* she sobbed, *the twilight of the Gods . . .* ▲

Marlene Dietrich has never even been *nominated* for an Academy Award. That's an historic injustice. Hey, Academy members! She still lives. In Paris. We should immediately deliver to Marlene Dietrich what we've freely given to lesser artists—*a golden Oscar for lifetime achievement.*

ANSEL ZONED

It couldn't have been a coincidence. He chose the date himself. On St. Valentine's day, 1979, for the first time in history, an artist literally bared his heart to an audience.

The exhibition, in San Francisco, was one of his smaller shows. Viewers were only a pride of doctors and a compassion of nurses. They took his heart in hand, replaced its clogged aortic valve with a section of pig tissue, and installed two bypasses made of veins from his leg. The exhibition lasted five and a half hours, during which his body was cooled to 60 degrees and his blood was circulated by a mechanical pump. When the show was over, they sewed him up better than new. After he returned to his home in Carmel, Adams wrote, *I could immediately walk further than was possible before the surgery, and I felt as good as ever, with the sort of energy I had thirty years before . . .*

Ansel Adams was always supercharged with energy. He was born in his parents' bed in San Francisco in 1902, soon revealed himself to be a *hyperactive* child. He ran around and got himself into trouble. He broke his nose running into a brick wall during the 1906 San Francisco earthquake, for the rest of his life wore his nose askew. In school, teachers couldn't handle him. He laughed at them, refused to do class assignments which didn't interest him. He got sick a lot—flu, nervousness, pneumonia, measles. Insatiably curious, he plagued his elders with questions like, *Does God go to the toilet?*

Parents of such kids usually resort to beatings, bribery, military school, utter neglect, or, these days, head doctors and suppressive drugs. Ansel's literate and resourceful parents Charles and Olive Adams knew better. They let Ansel quit school after the 8th grade (that was all the formal schooling he ever had) and took on the task of tutoring him at home—English, French, algebra, art, Greek, piano—and how to use his father's Kodak camera.

Ansel never did what he didn't want to do. But sometimes choices had to be made. In piano study he learned stick-to-it discipline for the first time, and liked it. He *practiced,* got good at Bach, looked forward to being a teacher himself and a concert artist. The eye-opening experience of visits to Yosemite, plus a look at the beautiful negatives of camera master Paul Strand, changed all that. Ansel Adams discovered what he needed to be—a *photographer*

The rest is public history, a life larger than life. In his 82 years Ansel Adams made more than 40,000 negatives and an uncountable magnitude of prints, portfolios, posters, calendars, letters, broadsides and books. His timing was just right. While his older colleague Edward Weston was glad during most of his lifetime to sell a photograph for $15 or $25, Ansel, during the 70s and 80s, presided over the transmogrification of photography as hobby into photography as a profitable fine art. His prints (and Edward's, posthumously) sold for $200, then for $5000, then for plus

or minus $100,000 for choice single works (most of these profits were realized by gallery dealers and resale by previous owners). Meanwhile, A.A. was also earning bushels of money from his book, poster and calendar sales.

Ansel became a media star, a millionaire. His elfin face smiled out from Time and Newsweek. He was big on radio, TV. His passionate advocacy of conservation brought him invitations to the White House from four presidents—Johnson, Ford, Carter and (yes) Reagan, each of whom he lobbied mercilessly for clean air, water, food, and for endangered species and forests. He told a bawdy joke that got bawdy laughter from Betty Ford. He listened impatiently as Ronald Reagan explained his own inaction by asserting there was *considerable scientific disagreement about the cause of acid rain.* Jimmy Carter hung around Ansel's neck The Presidential Medal of Freedom.

A.A. was the greatest teacher in the history of photography. During the 1950s he accepted a few hundred students at Art Center School Los Angeles. Over the years a few thousand attended his workshops at Yosemite, Carmel and San Francisco Art Institute. He taught and still teaches hundreds of thousands of students through his classic books on the art and techniques of photography, which have already sold more than a million copies. He invented and published *The Zone System,* which standardized film-sensitivity measurements so that photographers could

visualize the whole look and tonality of a photograph *before* exposure.

A.A. was an early member of the New York Photo League, a founder of the f64 Group in California (with Van Dyke, Cunningham, Weston), and a prime mover in establishing the Department of Photography at the Museum of Modern Art New York. He was (with Paul Strand, Beaumont and Nancy Newhall and Minor White) a founder of Aperture, New York, which publishes photographic books and an elegant journal of photography. He was founder and bountiful patron of the Center For Creative Photography in Tucson, Arizona (where his own photographic archive is now available for scholarly study) and of the Friends of Photography, Carmel, now grown into the Ansel Adams Center in downtown San Francisco, the largest non-profit photographic organization in the world.

A.A. was the best kind of friend one could hope to have. He was helpful, wise, tough, spontaneous, loving and funny. I met him at Edward Weston's house in the late 40s and enjoyed occasional hours of his company in later years—a seminar-lunch with a couple of other photographers at a fancy restaurant in Carmel, a Japanese dinner at his home with him and Virginia, his famous 5PM afterwork cocktail hours.

The day I made my *Ansel Zoned* portrait, in dappled sunlight outside his studio, I ventured to show him several of my own

138

recent photographs. He looked at them *thoroughly*, made perceptive comments. Then he took out a pen with a pure white circle on its cap, held it for comparison next to a white area on one of my prints. *Better check your safelight*, was all he said . . . When I got home I ran tests, found that the amber filter over my dark-room safelight had indeed faded over years of use; enough white light was getting through to fog slightly the bright areas of all my current work. Some prints had to be junked.

Ansel's oldest and greatest friend (aside from his forever wife Virginia) was his Carmel neighbor Edward Weston. They were a sort of Mutt and Jeff, Laurel and Hardy pair of opposites. Edward was small, thin, soft-spoken, monastic (except as regards women). Ansel was gregarious, joke-telling, physically big and mostly monogamous.

Edward and Ansel were brothers in photography through their adult years. They talked, argued, ate, drank, hiked, exhibited, and often photographed together. Ansel's only major modesty was expressed in Edward's direction. He told of how Edward had insisted he, Ansel, was *too involved in external problems such as conservation, museums and teaching . . . that I should make my life simpler and concentrate on creative work*. To which Ansel added: *He might be right*. Ansel once wrote a letter to Edward saying, *I believe you to be one of the greatest artists of our time—certainly the top man in photography . . .* to which Edward replied, *I don't think there ever is a "greatest"*.

Such judgments are perhaps best left to the years, and to posterity. Already by the early 90s many young photographers and collectors find Ansel Adams' photographs to be postcardy, overly dramatized with black skies, Wagnerian. It is already clear, however, that Ansel and Edward are both giants—and that in Ansel's case the genius of his work, as Edward suggested, has been obscured by his fame and by the media-star popularity of a very few of his 40,000 images: *Moon and Half Dome, Moonrise –Hernandez, Aspens, Clearing Winter Storm*, which have become cliches of American popular culture. Any serious study of the body of his work reveals an extraordinary variety of visual discoveries, equal to the work of almost any photographer who ever lived. Only in his people pictures and portraits (in my opinion) did Ansel's vision falter; surprisingly, they seem to capture little of the power, character insight and compassion achieved by such photographers as Dorthea Lange, Julia Margaret Cameron, Sebastiao Salgado—and Edward Weston.

Ansel timed everything in his life just right. His will was carefully lawyered into two trusts—one for publication rights (assuring continuous income to the estate) and one for disposition of his archive, dollars and property to family, institutions, environmental causes and friends.

By the end, when his heart finally gave

There was little sadness in Carmel at the Memorial Meeting and Concert for Ansel. It was more of a celebration of his work and life and friendship.

VIRGINA ADAMS WELCOMES A GUEST (upper left).

SENATOR ALAN CRANSTON AND FRIENDS.

PHOTOGRAPHY COLLECTORS LEONARD AND MARJORIE VERNON, WITH PHOTOGRAPHY DEALERS MAGGIE WESTON AND HARRY LUNN.

ANSEL'S VIEW OF POINT LOBOS AND THE SEA.

out, he was reigning lord of a capacious house and workshop on the Pacific shore near Point Lobos, with a regal staff including an enterprising business manager (Bill Turnage), a great Japanese cook (Fumiye Kodani) a visionary art dealer (Maggie Weston, once wife of Edward's son Cole), a succession of darkroom assistants (Ted Orland, Alan Ross, Chris Rainier, John Sexton—each a major photographer in his own right), technical advisors and helpers (including Edwin Land, inventor of the Polaroid camera), various doctors, lawyers, caterers, musicians, frequent friends, and, most importantly, Mary Alinder, an improbable combination of English major and registered nurse who regularly took Ansel's pulse and managed his staff. All this, and his loving and resourceful queen, Virginia.

Ansel's last major work was the *Autobiography,* which Mary Alinder edited and goaded him to finish. The great California printer David Gardner did the laser-scanned plates and presswork. Jim Alinder, then Director of Friends of Photography, did the cover portrait and biographical photos.

The *Autobiography* reveals an unexpected spiritual presence, of which few of his students and friends may have been aware. Here are a few of Ansel Adams' final words: *We all move on the fringes of eternity and are sometimes granted vistas through the fabric of illusion. Many refuse to admit it; some make mystical stews about it; I feel a mystery exists . . . After eighty years I* *scan a long perspective. I think of a mantra of Gaelic origin given me fifty years ago . . . It echoes everything I believe:*

I know that I am one with beauty.
And that my comrades are one.
Let our souls be mountains,
Let our spirits be stars,
Let our hearts be worlds. ▲

141

OLD MAN

He'd been prime minister of England during World War Two. He'd been a great writer and thunderer of English prose. Now he was old, sitting in the soft country sun, suffering the presence on his grounds of an American crew making a television movie about his other career—as a painter.

Among the several score books he'd authored was a small work titled *Painting As A Pastime*. This was to be the basic script for our film. I'd come over as director, expecting difficulty. How to make a 90-minute film (less commercials) about a third-rate painter? How could I do it without photographing the artist himself? By contract, not even still photographs of him were permitted, because, they told us, *The prime minister is an Old Man.*

His book was lyric, and passionate. When I walked into his studio I was flabbergasted. On every wall of the huge room, frame edge to frame edge and jampacked in closets, were his hundreds of paintings. Some, painted as early as the 1920s under influence of French friends like Paul Maze and Claude Monet, seemed to me beautiful. In the manor house itself one large landscape of the Old Man's hung boldly between two Monets. It did not seem to suffer.

When the film was done, before its international broadcast as a 90th birthday tribute, we arranged a preview at his London house. Halfway through the screening some incident or image caught his attention. He slowly raised his right painter's arm and pointed his forefinger at the screen. Then this War Lord of the West, this master of the language of Shakespeare, uttered one sound, loudly. *Duuuhhh . .* he intoned, and slowly lowered his arm . . .

This photograph of the Old Man was made by George King for British Information Services. My own photograph of the Old Man has to be stated in words only. Honoring my company's contract, I photographed him only in my mind's eye, after the film showing, as he welcomed family and guests into his sitting room for champagne and cigars.

There stands Winston Spencer Churchill before his crackling brightly-burning English fireplace, his rotund body erect in a green velvet jumpsuit. In one fist glows a Cuban cigar. In the other hand is a glass of champagne. He listens attentively to the prettiest woman in the room. Young, she wears a daringly low-cut gown, stands close to tell her story. Sir Winston's 90-year-old eyes shine bright in a rosy un-lined baby-face. He cannot speak. He holds eye contact with the lady. He smiles at her like a young satyr. ▲

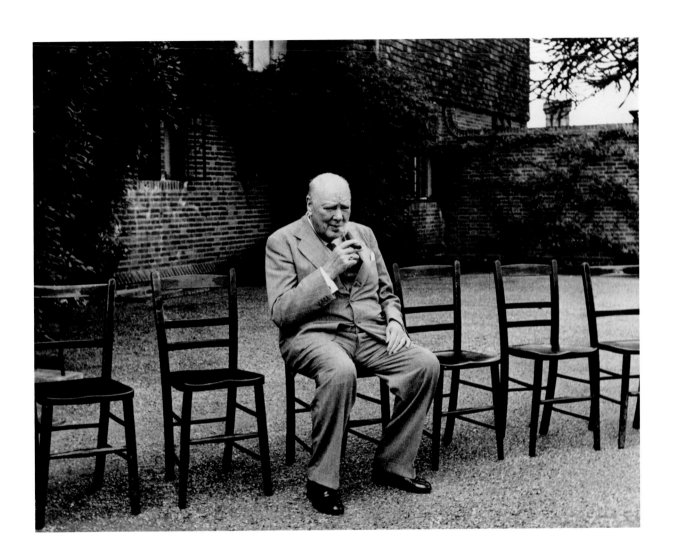

CAPTAIN INTEGRITY

Lifshitz? The Ellis Island clerk didn't think that name would work in America for the seven-year-old Polish kid. The year was 1903. Visiting New York harbor that same day was the famous racing yacht of Sir Thomas Lipton, the tea mogal. It gave the Immigration Officer an idea. *Your name is Lipton now,* he told the little Polack. *L-I-P-T-O-N, compeche?*

Chicago. Bright lad. Peddled newspapers. Turned on to poetry by public readings of Vachel Lindsay. Hung out with him, Ben Hecht, Harriet Monroe, Sadakichi Hartman, Carl Sandburg. Be a poet? First professional job at 16 writing for Frank Harris at Pearson's Magazine. Freelance writer. Publicist for movies at Fox.

Lost more than 100 family and friends to Hitler's ovens. World War Two secret agent for British Intelligence. After the war, agent for Irgun terrorists who blew the British out of Israel and established the Jewish state. Turned down invitation to emigrate to Israel and join the new government.

Hollywood. Wrote novels. Married mystery writer Craig Rice, third wife. Collaborated with her on more than 20 commercial books and screenplays (*Home Sweet Homicide, The Lucky Stiff*). After her alcoholism got worse, he did all the writing, still under her name.

Moved from Rice's Hollywood mansion to beach slum. Became prophet of the Beat movement in Venice (which he renamed Venice West). Married dancer Nettie Brooks and nursed her through tuberculosis. Published *Rainbow At Midnight* (poems) and two novels. Wrote several hundred angry honest weekly columns for Los Angeles Free Press. Muckraking commentator on KPFK radio. *Injustice Collector! Doctor Compassion! Captain Integrity! Old-Testament Clown!*

He and Nettie kept open house by the sea for teenage runaways, whores, painters, poets, junkies, Blacks, Chicanos, gays, lesbians, musicians, directors, actors, thieves, acid heads, feminists, lushes and other fugitives from Straight City. Drop-ins included Steve Allen, Kenneth Rexroth, Stuart Perkov, Lenore Kandel, Allan Ginsburg, Anais Nin, Digby Diehl, Shelley Manne, Buddy Colette, Clifford Irving, Irving Wallace, Robert Kirsch, Art Seidenbaum, Val Newton, Leonora Miller, Carlos Castaneda, Tim Leary. Nettie catered food and coffee, fed and loved them all, and held down a full-time editorial job at the University of California Press.

Lipton toured coffeehouses with his own Poetry and Jazz group. Produced recordings. Taught noisy popular courses in Avant Garde Literature at UCLA. Wrote *The Holy Barbarians* (about the Beats) and *The Erotic Revolution* (the Hippies). Lover of psychiatrist Karen Horney and movie star Linda Darnell, among others.

At age 70 Lipton joined the young protestors of the Vietnam war at the 1968 Democrat Convention—and got clubbed to

the ground by Chicago police. He was crippled, never walked quite straight again. The war continued six more years.

* * *

I remember one golden glassy California afternoon in the late '60s when I took Al Leslie, Don Devlin and Jack Kerouac to meet Lipton. Jack lurched through the bright alleys of Venice swinging his usual gallon jug of red wine.

Old Lipton and young Kerouac had fun meeting, each already legendary to the other. They tested each other, roosters in the literary barnyard. One contest was over the word *beat*. Larry said its origin was sociological, the beats were undergrounders *beat down* by society. Jack insisted on a spiritual origin. The word came, he argued with alcoholic charm, from *beatitude,* and what's more, he, Jack Kerouac, had first named the beat generation. *Maybe so, Jack,* Lipton allowed graciously, the two men laughing, liking each other. They agreed to give San Francisco columnist Herb Caen credit for *beatnik.* In 1969, back living with his mother in Florida, Jack Kerouac was suddenly dead, at 34. A strangulated hernia. He'd resisted for years the simple surgery that (with moderation of his boozing) might have given him another half century.

Lawrence Lipton was harder to kill. He didn't drink much, or dope hardly at all, and his cigars were usually unlighted.

There was teeth trouble. Stomach trouble. Sitting trouble and no exercise. Cancer of the rectum, cured by surgery. But thereafter the sore bottom, the air-filled rubber ring on the typing chair. Then came the strokes. Nettie nursed, and continued her own work at University of California Press. In 1975 the big artery burst in Lipton's brain. He was 77. The photograph on preceding page was made a few weeks before his death. Picture of Larry and Nettie at right (photographer unknown) is from the 1950s.

One surviving son, James Lipton, writer. Widow Nettie edited and published a book of his poems (*Bruno In Venice West*), dedicated, as Lipton had instructed, *for Giordano Bruno, burned by the Inquisition in 1600.* ▲

BIG SUR

OH, WOW!

In the early 1960s I saw in the streets and squares of London a few young men with shoulder-length hair and guitars. Their *birds* wore awfully short dresses. Local color, I thought. But when I came home to the States, closely followed by the music of a group improbably named The Beatles, the same faces and getups were here too. *Far out! Groovy! What's happening, man?*

Turned out it wasn't just Pre-Raphaelite hair on men, or invitational mini-skirts on women, or even the electric shocks of *rock and roll*. It was Revolution.

At first it was just teenagers, and sex. And that music. Then it was funny cigarettes, *Mary Juana* from Mexico. Then it was *Lucy in The Sky with Diamonds* (a Beatles song). *Cool!* Aldous Huxley wrote an influential book about his experience with hallucinogens. So did Allan Watts. So did Allen Ginsberg. *Tune in, turn on, drop out!* advised a defrocked Harvard professor. Hundreds of thousands followed Tim Leary's advice. A children's crusade set out from heartland America for *the Strip* in Los Angeles and *the Haight* in San Francisco. Lysergic acid diethylamide was available in the streets. A hippie genius named Owsley synthesized his own brand of Orange Sunshine. Novelist Ken Kesey (*One Flew Over the Cuckoo's Nest*) filled a school bus with *freaks* and went on tour, passing out free paper cups of, er, fruit punch. *Gloryowski!* exclaimed Little Orphan Annie from South Dakota as her assisted hormones began pinwheeling rainbows inside her head, heart and vagina.

American morals, lifestyles and politics were in upset and uproar. Religion was in danger. And the Family. The fabric of the Republic was unravelling! So California passed an anti-LSD law. So did Congress. But it was too late. Vanguard battalions of the young had stormed the Establishment—and were starting to turn on their parents, who figured they'd been missing out.

Fun thing is, the whole LSD connection was started back in the 50s by the CIA. *What?!* The CIA. The record's open now. Yes. Before any of the new drugs hit the streets, the federal spooks imported original Sandoz acid from Switzerland and covertly financed research with it at American universities and hospitals. CIA operatives also turned on some people privately, and watched, not telling them anything was going to happen. Like an acid mickey in their beer. So when it happened the people thought they were going crazy, and some did, and at least one died. No blame. The CIA's purpose was unassailably patriotic. They wanted to prove out for America a chemical weapon that could brainwash or incapacitate armies—and also perhaps create programmed assassins who, when caught, wouldn't remember who they worked for. Mind control. It didn't work. *Hah! Foiled again, Allan Dulles!*

149

OUTDOOR ROCK CONCERT Berkeley

1967 was the year of The Grateful Dead, Country Joe and The Fish, The Jefferson Airplane, and Gracie Slick singing *Ask Alice: One pill makes you smaller, one pill makes you tall, and the ones mother gives you don't do anything at all . . .*

It was the year of the first Human Be-in in Golden Gate Park, of flower friendships in the streets, of free food, free crash pads and free love. The Millennium!

Eden lasted only a year or two. Innocent l967, before People's Park, before the second Kennedy assassination, before Charlie Manson, long before Jim Jones and Guyana. Flower power got ripped off fast—by the media, tourists, VD, businessmen, speed, smack, narcs, trashing, guerilla politics, whirlypigs, its own simple-mindedness, and the metastasizing of the Vietnam War.

When Vietnam was over and Peace With Honor was ours, why Surprise! The Revolution at home had won. There'd been no armed insurrection. Only a few marches, desertions, strikes, immolations, bombings and shootings of students. The Government maintained, under different management. The Revolution, unbeknownst, had happened under the skin.

The changes had to do with consciousness, with matters like black pride, the empowerment of women, work worth doing, lives worth living, and a new passion for fresh air, clean water, natural foods, forests, and whales. Lots of people got religion (all sorts). *The best minds of my generation* had not all gone crazy as Allen Ginsberg wrote. Wiser and looser, they'd built families, gone into business, formed communes in Oregon, California, New York and Tennessee, become doctors, senators and judges, published magazines, planted forests, invested, filmed, farmed, taught, painted, performed, ministered, meditated and grew up. Despite everything they figured the US of A was indeed sweet compared to the lacks and uptightness of most other places.

There were casualties. Among those who didn't make it through the 60s and 70s were Jimmy Hendrix, Janis Joplin, Jim Morrison, John and Robert Kennedy, Lenny Bruce, Patrice Lumumba, Marilyn Monroe, Pope John, Malcolm X, Mark Rothko, Sharon Tate, Martin Luther King, three astronauts, four cosmonauts, a president of Czechoslovakia, a president of

DEMONSTRATION Los Angeles

151

Chile, 50,000 American soldiers, two million Vietnamese, Lyndon Johnson, Richard Nixon, Henry Kissinger, and thousands of war resisters, poets, teachers, revolutionaries, religious martyrs, scientists, prisoners, students, journalists, medics, dope heads, children, crazies and street people. Peace!

It was no coincidence that 60s ideas, lifestyles and rock music preceded the 1990s revolutions in Prague, Moscow, Warsaw, Bucharest, East Berlin and Capetown and are currently sneaking up on the Japanese. China, after Tienanmen Square, and the Middle East, after Ayatolla Komeni and Saddam Hussein, may take a little longer. ▲

OH, WOW! San Francisco

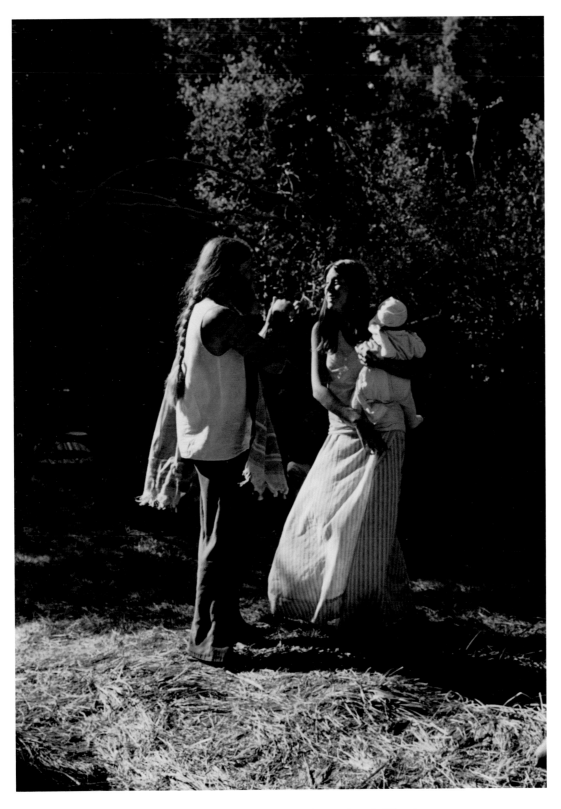

FAMILY AFTER SUFI WORSHIP SERVICE Clear Lake, California

AS FOR LIBERTY, YOU'LL NEVER
BE FREE UNTIL YOU'VE KNOWN
OPPRESSION, WHETHER BY A BULLY
OR AN IDEOLOGY, AND HAVE
WITHSTOOD THE HARASSMENT.

Marilyn Ferguson

four

NOW

SUBWAY New York City

TWO FAMILIES

The light of the body is the eye:
if therefore thine eye be single
thy whole body shall be full of light.
Matthew 6:22

On a recent journey through western states I met two young families each with a son named Matthew. We made photographs, exchanged greetings and addresses.

Larry, Karen and Matthew Irvin had been shopping in Salida, Colorado. They were about to take off for home in Poncha Springs, aboard their gleaming Honda motorcycle, when out of need I introduced myself and asked a favor. Would they lend me their son? Reason was, I'd just done a dumb thing and locked myself out of my van. A side window was open but it was too small for any adult. I needed a kid to crawl through and retrieve my keys. Larry laughed. *Sure thing,* he said. *I don't want to,* Matthew murmured. *Go on in,* Larry said gently, *Get the man his keys.* Matthew did. That's my rescued GMC van in the picture's background. Turned out the Irvin family's Honda motorcycle, though it looked showroom new, was exactly one year old that day and they were out celebrating its birthday.

* * *

Great Sands National Monument, also in Colorado, is a giant configuration of drifted dunes that awes and delights children and adults.

I met Tim and Marci Bachicha trudging through the sands, young Matthew on Tim's back. Tim is a carpenter from Alamosa. They are a warm enthusiastic Christian family. Tim started in on me at once. Had I been saved? When we parted he tore a page of thoughts from his notebook for me to read and wished me God's blessings. Later he sent me printed literature and a concerned loving letter, which I'll finally answer here.

Dear Tim: When I was five years old a favorite neighbor lady who told stories and baked cookies decided it was her Christian duty to take me on her lap and say If you don't believe on Our Lord Jesus Christ you're going to burn in hell. I ran home in desperate tears to my Jewish mother. Since then I've sat with Buddhists, Catholics, Moslems, Hindus and Taoists, and with smaller families like Jews, Quakers, Sufis, Bahais and Aricans, and with true believers in Psychology, Art, Science, Pleasure, Politics and Sports. I found almost all of them honest good-hearted people and the world a better place for their individual witnessing.

So I can't join up anywhere, Tim. I'm turned off by the way Believers have cut each other up throughout history in the name of their particular version of God, and still do. Besides, I feel born again every morning my eyes open from sleep. Thanks for caring. My love to you, and to Marci and Matthew . . . ▲

FAMILY Jilotopec, Mexico

FAMILY New York City

PAULINE

We'd been casual friends for twenty years, she as film critic for The New Yorker, myself as filmmaker and professor. Every two or three years we'd run into each other at movie festivals, on campuses, at airports. This time I was halfway through eggs and toast at the Algonquin when in bustled Pauline exuding from her woolen coat and flushed cheeks the cold of a severe Manhattan morning.

I proselytized her as usual to come join our film faculty at UCLA. *The students need you,* I said. *We might be able to arrange a Regent's Professorship. Perhaps,* she replied as usual. *Yes, perhaps I could manage it for next spring when I'm not reviewing.* Then we talked about films, and film friends we shared—Ernest in Berkeley, Colin in London, Kershner in Los Angeles. And it suddenly struck me that this lively subtle woman's whole life was film. I know very little about Pauline Kael, whether she's married and/or has a lover or is celibate, whether she's rich or poor, churched, political, healthy. What everybody does know about her is the brightness and convincing rightness of her expression.

Of Warren Beatty's *Heaven Can Wait*, she typically wrote: *The film has no desire but to please, and that's its only compulsiveness; it's so timed and pleated and smoothed that it's sliding right off the screen.* Of Mike Nichols' *Postcards From the Edge* : *Meryl Streep just about always seems miscast . . . Nichols directs Shirley McLaine to overdo the mother's self-preoccupation . . . The assumption of Postcards is the assumption of the* tabloids: *that all any of us want is to be movie stars, and we despise the ordinary Joes who aren't rich. If Nichols were up front about what he is doing, we might enjoy his pissing on the yearnings of squares, but Postcards is jadedness pretending warm good will.*

Kevin Costner, director and star of *Dances With Wolves,* took a body blow: *He had feathers in his hair and feathers in his head,* Pauline wrote. *When that film wins its Oscars* (which indeed it did), *I'll just laugh.*

After breakfast, on the street, I raised my camera. Pauline immediately took off her glasses. *You prefer them off?* I asked. There came into her face and speech a moment of satisfied pause. I made this picture. Pauline Kael.

The question about the glasses bothered her. She could admit no implication of vanity. Perhaps there was no vanity, only her critic's sense of rightness. *It's just that glasses occupy so much of the face,* she said, and smiled, pleased she'd managed to say something to the point and amusing. ▲

In Spring of 1991 Pauline Kael quit regular reviewing, though she still writes occasionally for the New Yorker. Her editor Robert Gottlieb's sendoff in the New York Times: *A whole generation of film critics has had to respond to her either by imitating her or resisting her . . . Readers throughout these 20-odd years have had to read her, whether they agreed with her or not, for the passion of her ideas and the excitement of her prose.*

MEMORIAL DAY

A certain gleeful guilt stays all their lives with men who survive war. This kind of guilt does not have to do with the killing of enemy soldiers or civilians. It has to do with comradeship, with mystery. *How come my buddy died and I survived?*

One soft spring morning 33 years after World War Two ended I turned the pages of my Los Angeles Times and came upon a United Press story that stopped my breath:

> *TOKYO—Japanese authorities have released the names of 17 American prisoners of war killed in the atomic bombing of Hiroshima in the last days of World War Two . . . Six of the dead were crewmen of a B-29 shot down over Japan's southern island of Kyushu in May, 1944:*
>
> *2nd Lt. William Fedwicks*
> *Sgt. T. Lolocker*
> *Cpl. John C. Kolehor*
> *Cpl. Robert B. Williams*
> *Cpl. Leon E. Kuzanik*
> *Dale Blanbeck, no rank given*

In May of 1944 I lived in China barracks with these men before we flew out together on the first B-29 raid against Japan. My aircraft came back. They'd gone down in fire over Yawata, Kyushu. Half their 12-man crew apparently died in the crash, or soon afterwards (angry Japanese farmers with pitchforks?). These six Americans survived, were captured, lived in Hiroshima prison, died with 74,000 Japanese in the furnace of the first American atomic blast . . .

On Memorial Day a third of a century later I visited the veterans' cemetery in Los Angeles and made this photograph.

Very few widows, parents, children or old buddies had come to visit the graves. World War Two, Korea, even Vietnam were history. It was a lovely day for the beach. One solitary man parked his silver Volkswagen among the headstones and searched to find a name.

*　　*　　*

In 1982 I visited Yawata again, on the ground. And I walked the irradiated ground of Hiroshima. At both places I bowed my head and placed chrysanthemums. I mourned for lost comrades and onetime enemies and asked forgiveness, and cried.

Then, leaving, I smiled up into the Japanese sky and breathed deeply, grateful to have had for myself good use of all these years. ▲

LAST CLASS AT UCLA FILM/TV SCHOOL

I focused the little camera, released its delayed action shutter, and ran around the table to pose with my students. We all laughed as the camera buzzed, kept blinking a red warning, then clicked our picture.

After 23 years of professoring, at 71, I'd been required by law to retire because of age. This session of Screenwriting 130A was my last class. I got a round of applause, a couple of handshakes and hugs, and one surprise kiss. Back in my office, all packed and ready to go, I read a couple of late student papers, completed my final grade reports (one C-, three B's and the rest A's, and expected to be—happy. I wasn't. Why?

I'd looked forward to retirement. No more obligation ever to clock and calendar. Escape at last from the hustle of Los Angeles. A new life in the clean air and redwoods of northern California. Full time for friends, fun, daughters, grandchildren and my own writing and photography. A reduced income, true—but enough earned from Social Security and UC pension to live in prudent comfort. So why was I ill at ease? I was worried about my students. They, and the next generation, and the ones after that, couldn't know what they were up against.

The word *University* has a noble ring—like *Law, Religion, Nation, Art, Savings Bank, Home, Family.* But all our institutions now seem to be under stress. Wars are made to happen. Homeless families sleep and starve in the streets of rich cities. High-living bankers, brokers, developers and politicians make off unscathed with billions of the people's money. A genial lazy air-headed American president survives eight years of office trailing lies, greed, malfeasance and an economy tottering under debt greater than the *total* of debt incurred by all administrations since George Washington's.

Under such circumstances it should be no surprise that the institution of the University is also under duress. I feel obligated to speak out here in defense of my students and their university, and mine. The truth is, friends, our university is run primarily for the aggrandizement of the Regents, the Chancellors, the Deans, their staffs and then the Faculty. Students come last . . . Hard to believe? Check out the following LA Times news story.

Regents OK pay boost for UC leaders

McClatchy News Service

LOS ANGELES — Lamenting that a tight state budget forced them to raise student fees and cut programs, University of California regents on Friday approved salary raises ranging from 5.8 percent to 7 percent for the system's top leaders.

Under a pay raise schedule approved by the regents with no public discussion, UC President David Gardner and the system's nine campus chancellors will get raises on Jan. 1. Gardner's pay will rise from $230,600 to $243,500. For eight chancellors, Friday's raise was the third in 18 months. Their average salary will be $164,755.

The regents voted also on Friday to give an average 7 percent raise to about 350 administrators and senior staff members scattered throughout the UC system. Their raises will take effect Jan. 1.

He said he would request a small increase in the $2 billion management fee UC is given each year to operate the labs.

The connection between UC a the labs has come under fire some faculty and students beca they say a university should no linked to the research and te: of nuclear weapons.

165

I came to UCLA in the early 60s. It was a good time. We had a younger more energetic faculty. The film building had not yet been built. Screenings, teaching and film-making happened in a temporary U.S. Army barracks left over from World War Two. Our students were hot for film and included such future achievers as Frances Ford Coppola (*The Godfather*), Colin Higgins (*Harold and Maude*); Penelope Speheris (*The Decline and Fall of Western Civilization*) and such inventors of new film forms as Burt Gershfield (*Now That*

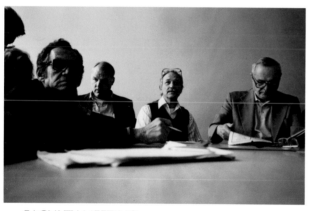

FACULTY MEETING

The Buffalo Are Gone) and Donna Dietch (surreal Lesbian short films that broke artistic, technical and sociological ground). Ray Manzarek and Jim Morrison, who were soon to be keyboardist and lead singer of the Doors rock group (*Light My Fire!*) were also with us. The visionary film-maker Louis Schwartzburg (later responsible for much of the dream-world imagery in *Koyaniskatsi*) showed spectacular special effects.

Our department chairman was a cheerful young film scholar from England, Colin Young, whose love of movies was contagious. Chancellor of the University was Dr. Franklin Murphy, a polymath medical doctor (non-practicing). He loved the arts, the sciences and students, and was responsible for creating on campus one of the great sculpture gardens of the world, featuring major works by Maillol, Rodin, Henry Moore, and maybe fifty other international masters. Also featured in the green, rolling landscape of the sculpture garden were curvilinear cement study nests where faculty could schedule small classes. Among the sculptures, under the purple flowering of the jacaranda trees in Spring, we could imagine ourselves as Socrates and his students teaching each other in the gardens of ancient Greece.

All these good vibes seemed to end abruptly with the near simultaneous resignation of Colin Young from the Film Department Chairmanship (to become head of The National Film School of Great Britain), retirement from the Chancellorship of the good Dr. Murphy (now a top exec of Times Mirror Publishing), student protests nationwide against the Vietnam war, and appointment to the UCLA Chancellorship of Dr. Charles Edward Young, a handsome ambitious young man of no particular scholarly distinction.

Chancellor Young did know how to drink with the boys, or alone, and once set an example for our 34,000 students by being

arrested for drunk driving after smashing himself into a campus tree in a single car accident at 2AM.

He also knew how to raise money from rich alumni, build buildings and parking structures all over campus, and, as Associate Professor, taught occasional courses in Political Science (whatever that oxymoron means).

Chancellor Young enjoys lucrative memberships on the board of directors of several corporations (UMF Systems, Intel Corp, Maxicare Health Plans, etc.) and was once honored by the Westwood Junior Chamber of Commerce as Young Man of the Year. On no occasion involving faculty or students did I observe him as warm, truly courteous, or receptive to the needs and ideas of subordinates. Only once did I see expressed on his public face honest pleasure—a news photo showing him in a state of high glee as he bearhugs a ball player who's just made a touchdown.

The Chancellor did finally achieve construction of the film building. It emerged as a claustrophobic design with a good movie theater but too few classrooms, editing rooms and, especially, windows.

Without consulting faculty or students (except probably a couple of senior faculty members), the Chancellor ordained that the new film building was to be named Melnitz Hall. *Melnitz? Who's Melnitz?* our students wanted to know. W. W. Melnitz was a respected senior professor of *Theater*

with lots of experience and credits in Europe as producer and director of stageplays. He had no experience with film production, taught no film courses. All our student body and almost all faculty felt betrayed. But the name stayed on the building, in brass letters. Our faculty and students would have preferred *D. W. Griffith Hall* or *The Frances Ford Coppola Film/TV Center* (with a marquee out front of the lobby)! But nobody asked us.

Chancellor Young's building mania finally came a cropper in 1990 when outraged students, local homeowners, the LA Times and elected city fathers forced cancellation of most of his pharaonic plan to add more than *four million* square feet of building to UCLA's already city-size proportions. Especially resented and eliminated was his plan for a Conference Center with a huge auditorium, a parking structure, a restaurant and hotel rooms for 300 overnight guests. This developer's wet-dream was to be erected at the southwest corner of campus on Wilshire Boulevard—which is precisely where that stop-and-go, dodge-and-cough thoroughfare had already earned the dual distinction of Most Polluted and Most Congested among all of Los Angeles' celebrated motorways.

Probably the most demoralizing damage Chancellor Young succeeded in achieving at UCLA was *disestablishment of the College of Fine Arts.* Presto vanish! The whole College of Fine Arts including the disciplines of music, dance, painting, sculpture, photography, theater, film and TV were summarily

marked to be dismembered and de-named. The broken fragments of the College were told they would each be assimilated within other university Colleges or, possibly, become independent mainly graduate-level *Schools*.

To begin with, the Chancellor decreed, all film/TV professors teaching theory and history (about ten of our youngest and brightest teachers) would transfer themselves and their classes to the College of Letters and Sciences (where, we all knew, they would immediately be eaten by senior English professors who were having trouble attracting students to their own stodgy classes). UCLA's English Department, for obscure reasons, emphasizes the study of John Dryden and other minor 17th century English poets and playwrights but is short on classes and faculty teaching creative writing and contemporary literature. Unanimous faculty and student refusal foiled the Chancellor's ploy to deport our film studies classes and colleagues to the 17th century.

Why should a Chancellor undertake such major academic mischief? In the case of Charles Young versus the College of Fine Arts the logic seems to be a stew of ego, politics and money. He stated he wanted professional graduate theaters on campus for dance, theater and film, whereby he hoped to involve the prestige (and money) of the neighboring solid-gold Getty and Norton Simon museums—*at the expense of undergraduate studies.*

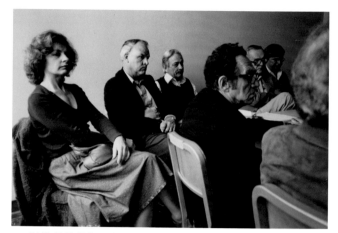

WE DO SO HAVE WOMEN PROFESSORS.

Perhaps over the years the College of Fine Arts had become *too* successful. Thousands of students kept trying to enroll each year for a few hundred openings—whereas the College of Letters and Sciences, apparently the Chancellor's favorite, was having a hard time keeping their students interested. Moreover, College of Fine Arts students, like most artists, were likely to be questioners, trouble-makers, peaceniks, feminists and tree-huggers, not enough interested either in sports or elite graduate studies.

Root problem was perhaps the Chancellor's own misunderstanding of what art is, why it is valuable and how it is made. *Look,* the Chancellor told us, *UCLA is not a trade school, especially not on the undergraduate level. Undergraduate students should study the history and theory of their art before they actually practice it.*

I know no professors or students from the late College of Fine Arts who were against the study of history and theory in their

disciplines. Critical studies classes, especially those involving film screenings, are avidly attended. But any freshman artist in any medium could have instructed the Chancellor of UCLA that in the arts *you can't separate practice from theory.*

Besides, few students of the arts come to tax-supported UCLA from all over California and the world with the money, time or interest for years of theoretical study before actually producing art. To them *the primacy of making and doing* is clear. Not so for Charles Young. Still, nobody ever heard the Chancellor advocate that undergraduate *athletes* should spend four years studying kinesiology and the history of sports before earning their graduate degrees by actually playing ball games.

UCLA has been known to graduate super athletes who couldn't do math, or read English at an 8th grade level. So when upon graduation they found they weren't good enough to join professional ball clubs at million-dollar salaries they simply flunked out of life and hope.

* * *

Professors have a way of dying, or retiring. As UCLA senior professors of film-making disappeared they were somehow not replaced. Undergraduate students who signed up for courses in acting, cinematography, film editing, screenwriting, sound recording, direction and producing found there *were* no classes, or classes were full, or for graduate students only.

As for new undergraduate admissions, they fell drastically each year. There were *no* freshman admissions. And *no* sophomore admissions. You had to be a junior before admission to the Temple. Meanwhile, a new *doctoral* program was instituted, requiring lots of faculty time and admitting very few students.

Typical of how Chancellor Young went about disestablishing the College of Fine Arts was the way he sent his newly appointed Dean of the College, Professor Robert Gray, to address our faculty. *You've been asking for more budget and more faculty,* he told us. *I know your cameras are old and worn out. I know you need more space and more technical staff. I think I can get these things for you. However, the Chancellor and I are not satisfied that you are all doing your best with present resources. We want you now to initiate an in-depth departmental Self-Review. How is the department now operating? How, ideally, should it work? I want you to interview each other, in depth. Discussion and recommendations should be without limits. Take your time.*

This work took more than two years. But at last the fat Self-Review document was finished. Dean Gray told us he was pleased. He'd present it now to the Chancellor and was confident our wishes and needs would be met. Dean Gray was an innocent, too much artist and honest man instead of politician. Urging our proposals

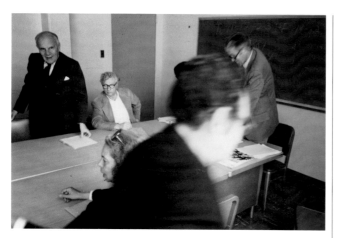

SENIOR FACULTY PLAYS MUSICAL CHAIRS.

on Chancellor Young got him summarily
fired (or forced to quit?). In three days
Robert Gray was back in the Art Depart-
ment (School?) to teach painting, which he
is good at . . . *Had UCLA become Alice's
Wonderland? The set for a movie by
Kafka?*

* * *

Instead of trying to explain these events to
our faculty and students, the Chancellor
threw us a big Machiavellian bone. *OK,
you guys,* he told us, *you can be a SCHOOL.
Independent! With your own Dean!*

Great, most of us thought. At last. But the
question of undergraduate film production
was left suspiciously undefined. Over the
following *three years* no new Dean was
appointed. A long-time woman assistant
of the Chancellor's was sent over from his
office to be *Acting* Dean.

In the Spring of 1991, under shadow of the
Gulf war, Chancellor Young appointed the

Chairman of the *English* Department,
Professor Daniel Calder to be our Associ-
ate Dean. And he hired one Gilbert Gates,
a Hollywood producer-director, as our
Dean. Gates' principal recent distinction
was to produce the annual Academy
Awards TV extravaganza. *Glitz rules!* . . .
Latest order from the Chancellor (via his
Dean's office) is that new Film/TV under-
graduate enrollment each year shall be
only *twenty* students (juniors and seniors
only) and *six* new graduate students . . .
*It urgently seems time for the Academic
Senate to invite Chancellor Young to hang up
his fool's cap and retire.*

* * *

We are all teachers. Parents to children.
Children to parents. Neighbor to neigh-
bor. Ourselves to ourselves. Friends and
lovers to each other.

When the teaching relationship becomes
institutionalized—priest, coach, master,
spouse, nurse, doctor, shaman, political
leader, professor—new depths of responsi-
bility and possibility emerge. There come
times when you deeply understand that
teaching is a two-way street. You learn at
least as much as you teach. A certain joy
happens. You learn from your students
the most wonderful lesson of all: *these kids
are family.*

I lived alone during most of my years at
UCLA. But my students were present or
in awareness all my waking hours. Like a
parent, I found excuse for their lapses,
pride in their achievements, trusted them

to do things right—and they mostly did. I fathered, taught, mentored, loved and learned.

Now that all of us have left our academic home, students to the working world, myself to supposed retirement, the magnitude and durability of familial relationship become even more poignant.

Most men and women have parents, a sibling or three, spouses, grandparents if we're lucky, a child or more of our own. I've enjoyed and suffered all of that. But as parents and grandparents have gone, children, grandchildren, ex-wives and myself moved to far places, I find to my delight I have *thousands* of children. Many telephone, send letters and Christmas cards. They come visit, bring screenplays, photographs, book manuscripts, films and tapes for my study and critique. Would I write a letter of recommendation? I show them my own work in progress, benefit always from their fresh views.

I walk the streets of London, Tokyo, New York, San Francisco, San Juan and Mexico City and am suddenly accosted by smiling strangers: *Aren't you Lou Stoumen?* they ask, after all the years. We inspect each other, recognize, embrace.

Best fun, like a father or mother's pride, is when your old students *achieve.* You watch PBS environmental documentaries and Bill Moyer's powerful interviews and there on the credits crawl the names of film editors John Soh and Michael Collins.

Lynette and Trevor Black sell their first screenplay, then write, direct and produce their first feature, *Last of the Golden Bears.* Sonoko Kondo publishes op-ed page essays for LA Times and LA Examiner, now travels to international film festivals buying rights for a Japanese company— meanwhile marrying a considerable artist, becoming a mother, publishing a cookbook (*The Poetical Pursuit of Food*) and producing her first feature film. V.V. Hsu (pronounced *Shoe*) writes and directs her first feature, *Pale Blood.* Chick Strand makes experimental non-commercial films and wins a Guggenheim Fellowship. Courtney White publishes his first book, an original exposition on field archeology and anthropology, illustrated with his own photographs. Carlos Castañeda publishes *The Teachings of Don Juan* (he wasn't actually my student but we were professor-student friends and co-conspirators; the first *Don Juan* book was his UCLA thesis). Mina Milani gets her own late-night radio show, does voice-over gigs, and writes screenplays. Tracy Briery publishes her first novel, *The Vampire Memoirs,* which started as a screenplay in our writing class.

Jeff Obrow! Luli Barzman! Charles Solomon! Sam Aslanian! Laura Schaefer! Scott Cooper! Many many others. Achievers all . . . Lauren Kusmeider teaches film in Florida. Alex Cox makes *Repo Man* and *Sid and Nancy.* Carolyn Reuben writes a medical column for LA Weekly, publishes authoritative health books. Gregory Nava and Anna Thomas write and direct *El Norte.* Linda Niemann publishes her

poetic autobiographical novel *Boomer* (somebody should make it a movie).

Charles Burnett, a modest young man from South Carolina who startled UCLA with his seamless compassionate student films about black life in Watts, writes and directs poetic movies like *Killer of Sheep* (1977) and, most recently, *To Sleep With Anger*, which got awards and standing ovations at French, Italian and Western hemisphere film festivals and glowing reviews world-wide. Sweet icing on Charles Burnett's cake was his recent recognition by the McArthur Foundation in the form of a $250,000 grant in support of his work. ▲

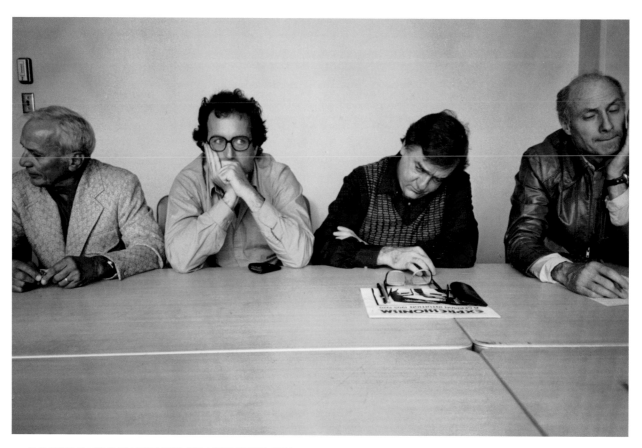

JUNIOR FACULTY CONTEMPLATES ETERNITY . . .

Following World War II, in 1945, the annual production of industrial chemicals on this planet was about eight million tons. By 1985 it was one hundred and eight million tons. And by the year 2000? . . .

She hadn't been able for many weeks to find meat of a purity her body could accept. She had learned it was wise to respect her body's hungers. Now it wanted protein. Meat.

Through her telephone network of friends she located a young, range-grown, chemistry-free lamb—and a farmer-butcher up in rural Sebastopol who understood her problem. Mr. Albini slaughtered the lamb for her, prepared and wrapped its parts according to instructions, and carried the sealed bags to my swept and aired van. I drove south through San Francisco to Berkeley and delivered the bags to Stanley, a neighbor and helper of Elna's who kept a large freezer in his apartment. Then I stopped by Elna's to greet her and report the delivery.

In her early 50s now, Elna Widell is a comely loving bright young woman, as curious energetic and creative as each varying day permits. Like many thousands of other victims internationally, she suffers from Multiple Chemical Sensitivity (MCS), also known as Environmental Illness (EI).

For more than nine years now she has lived a prisoner in one stripped-down room of an apartment near the campus of the University of California, Berkeley. So far she has managed to cope in a life situation almost inconceivable to the rest of us. She reads no daily newspapers or books (ink fumes). She has no television (electro-magnetic waves). She has no stove; cooking is achieved in a slow-heating electric ceramic crock-pot. Hot water comes from a gas water-heater specially sealed from her room. She enjoys no heat at all as fumes from an electric or gas heater or a wood burning stove would make her instantly ill. Northern California winters can be severe; Elna survives them by shrouding herself in cotton cloth and, on especially cold days, burrowing into her narrow bed under many blankets and hoping for Spring.

She does have an elderly portable radio and a telephone, both partly plastic, but old enough to be free of chemical fumes. She has part-time student helpers who shop for her and open and read her the mail. Elna keeps up her correspondence, writing in pencil, and asks her friends to do the same—ink and some papers cannot be tolerated. Friends can come visit by way of conversation through her open door or, loudly, through the glass of her kitchen window, or, rarely, when the sun and air are just right, she can greet friends outdoors in the yard of her house. Kissing and hugging are not possible—Elna instantly and strongly reacts to body odors, cologne, perfume, cosmetics, most soaps, recently dry-cleaned clothes—as well as to smog, solvents, photographic chemicals, felt-tip markers, chlorine, air

freshener, pesticides, molds, plastics, incense, plywood, gasoline, kerosene and many other food and consumer goodies available in drugstores, newsstands, bookstores and supermarkets. Her body can tolerate no grains, fruits or dairy foods.

Elna's efforts to relocate to a cleaner environment in an area with a warm dry climate have been unsuccessful to date. She looks forward to the day when she can once again walk about under the open sky without being incapacitated by environmental fumes. Others who find themselves in Elna's predicament live (if they can afford it) in porcelain rooms or custom, no-plywood house trailers and/or in special places such as the foothills of Mount Shasta, the Arizona high desert and unindustrial small islands. They wear gas masks when unavoidably exposed to chemical threat, carry tanks of pure oxygen. The increasing incidence of EI victims is international. Mexico City, Los Angeles, Tokyo, the Persian Gulf and many parts of formerly Communist Europe and the Soviet Union are among the world's hot spots of pollution and EI victims, including children. There is now abundant and convincing evidence that our whole planet—its air, water, earth and life forms—is environmentally ill. Some scientists say this deadly process may already have accelerated to such degree as to be irreversible.

For EI victims, there is so far no known cure. Selective organic diets, exercises like yoga and tai-chi, meditative spiritual practices and leaving cities for clean-air

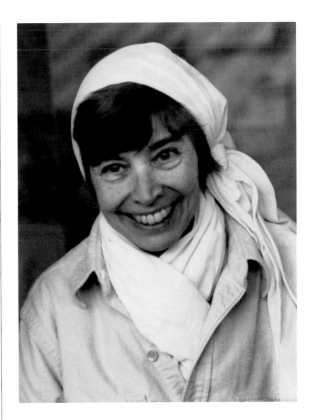

places have resulted in improvement for some, even substantial remission of sensitivity and symptoms.

* * *

I knew Elna Widell when she was whole, in the early 70s. Behind her then was Radcliffe College, *wanderjahren* in Europe and Mexico as companion of the late great photographer Ernst Haas, and school teaching in Italy and New York City. She happened upon northern California in the late 60s, found the life-style compatible and stayed on, studying biological sciences and Buddhism at UC Berkeley.

When I met Elna she was writing a sci-fi

175

futurist novel and living in a simple elegant redwood house she had designed and built herself (with the help of friends) in forested foothills a few miles inland from Bodega Bay. She earned her living by owning a flock of sheep, putting them out to graze, doctoring them for worms, shearing their wool, helping them birth their young, and selling them.

The last time we went out together was a sunshiny, smog-free day in early Spring. *Come,* I urged, *we'll just drive over the bridge to the Marina. We'll watch the boats and the gulls and breath sea air.*

Yes, Elna said, *I think I can do that today.* This was the first time she'd been out of her apartment in many weeks. She blossomed visibly. *Look at that!* she said. *Look! Look!* Like a child in wonder. A tour bus paused behind our parked car at the Marina, took off with a belch of black exhaust fumes.

Oh! said Elna. We rolled up the windows, drove slowly back to Berkeley. Elna was slumped down in her seat like a rag doll, her face ashen and puffy, eyes inflamed, breath labored . . .

Last Christmas Elna sent me a short poem, *The Exile's Song,* first piece of sustained writing she'd achieved in years. I wondered: *Could the writing of this poem be a harbinger of her cure?*

I was moved by this work. And I presume, since you have read this far, that you too might value Elna's *Song.* With her permission, and her respectful regards to you, here it is . . .

* * *

THE EXILE'S SONG
—A Season's Greeting

I. THIS FOREIGN LAND

Even in exile there are seasons.
The light slants in from lower down
 these darker days.
Last leaves cling to the garden trees
 as sap recedes to subterranean
 chambers.

In that other place
 we lit the fires and sang the
 songs
 gathering close with winter's coming.

How does it work in this country
 I have come to inhabit,
 a refugee
 cut off from fire and friend alike
 by the walls of this solitary cell?
What song celebrates earth's turning here
 through darkening days
 toward new light?

Inside my blood the sickness swirls
 and memories.
Outside my window
 a patch of garden
 a piece of sky.

This is my world now. I am listening
 for the song of this place,
 a song to send back to my brethren.

As winter moon crosses my window
 tides rise within my heart
 wave upon cresting wave—
 and ebb to empty still
 silence.

My eyes at the window are hungry
 to drink whatever is given
 of darkness
 and light
 in this strange land.

II. THE SEASONS OF DARK
 AND LIGHT

The task of the exile is to return
 to a land that can never be
 found
 as once it was
 (the leaves of the apple tree
 drift past the window).

So much of that other life
 abandoned in hasty departure
 still cries out for expression—
 to ride a horse, birth a lamb,
 read a book, write a story,
 hold a lover, hug a friend,
 engage a child's curiosity . . .

 (The apple was butchered in
pruning last year—it's graceful limbs
 reduced to stubs—

but put forth blossom and green
at all angles
 a plethora of thin wands
 clustering at each amputation
signaling with bushy disarray
an irrepressible thrust
 toward life.)

Ghosts and shadows parade
 all that has been
 and is to come
 what might have been
 what might still be . . .
 if only—
 if only—

 (The young squirrel hangs
by the toenails of his hind feet
 as he stretches precariously
 for the last figs.
 In his first year of life
 he confidently casts himself forth
 into each new day, harvesting what-
 ever is.)

Is there a path back
 to be among you again?

 (On a certain day as the world
winds down toward darkness
the sun sets between the apple and the fig,
 and farther in the distance between
 the pine and redwood
 in that narrow alley of sky
 dipping down to the garden fence.
Golden beams slant in, my room becomes
 an ancient temple
 marking the year's turning.

FATHER AND SON

It's hard for a middle-class white boy to figure what it's like to wear black skin on the streets of Nueva York during this dangerous hopeful last decade of the 20th century.

If Bill Cosby or Alice Walker came to dinner the difference of race might quickly be e-raced by the universal solvents of fame, bank account, literacy and friendship. But a struggling black man, a black boy, from the streets of Harlem? Or from Watts? Soweto? The all too durable stereotype says they don't belong in the plantation parlor, 'cept as servants. Watch your silver. Watch your women. Cover your back. Die a little.

I caught sight of them on Broadway near 43rd Street. Father and son surely. Taking their photograph wasn't easy. The sidewalks were crowded. They didn't dawdle at shop windows. I didn't want to ask them to pose—the pictures are never as real. Besides, some errand seemed underway. A job for the man? Special classes for the kid? Reunion with wife and mother?

Near 47th Street an opening appeared in their shield of passersby. My camera eye blinked open for 1/250th of a second, a tiny time bite now preserved out of all eternity. The alert streetwise man, the wide-eyed boy. Their hands firmly clasped. As indubitable an image of love and care as a Leonardo painting of Madonna and Child . . .

Their image quickly submerged in Times Square's human sea . . . ▲

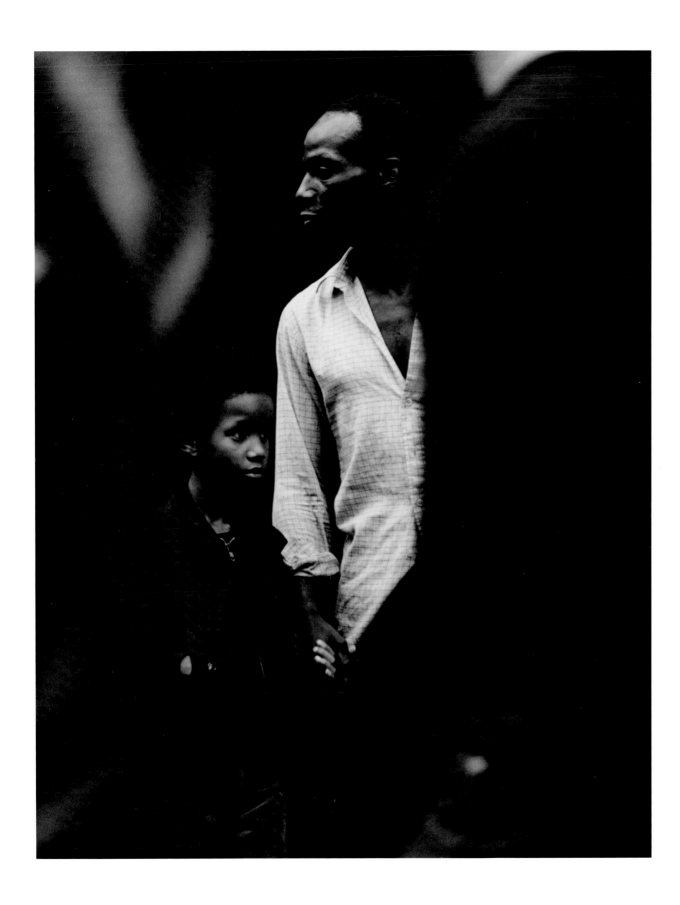

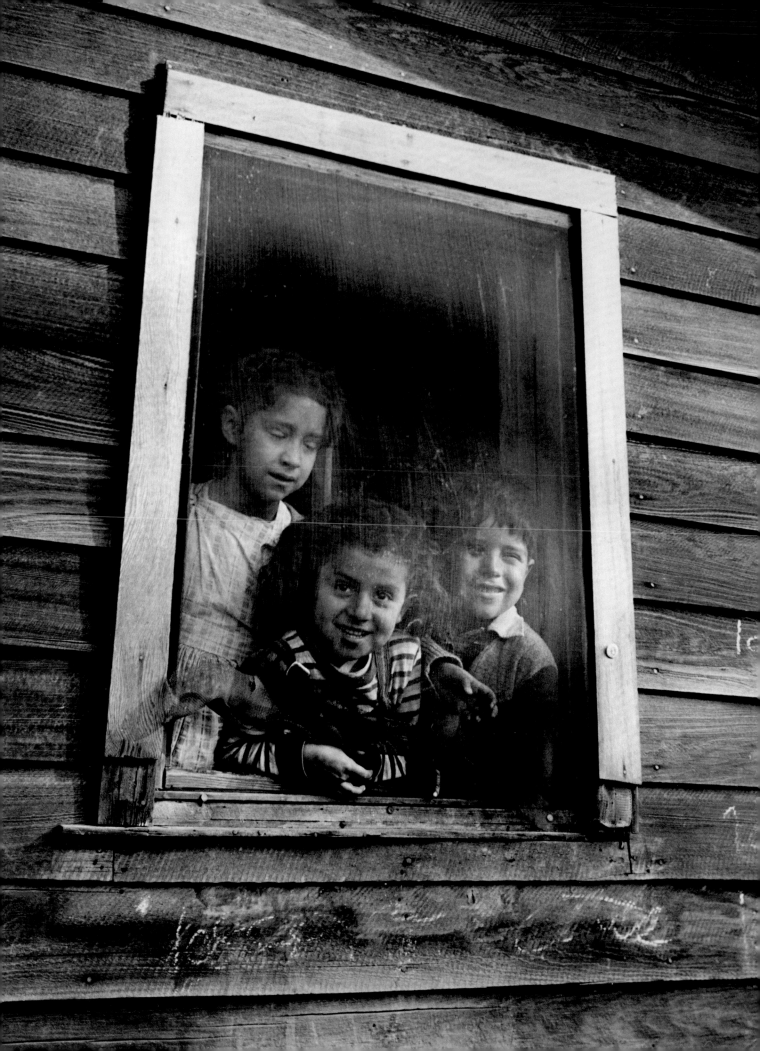

IN SPITE OF EVERYTHING,
YES!

Ralph Steiner

five

GALLERY

CHILDREN East Los Angeles

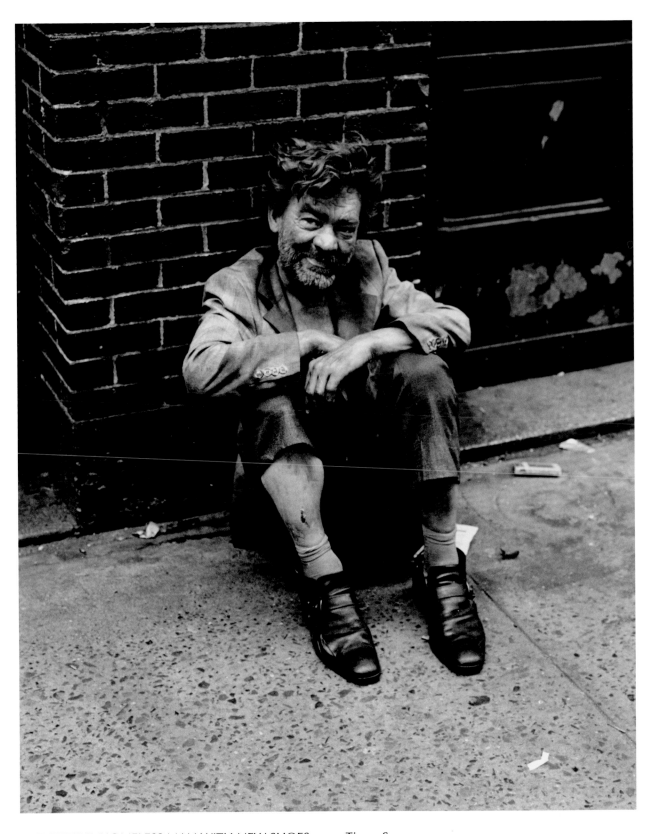

CHEERFUL HOMELESS MAN WITH NEW SHOES Times Square

THE BOOTS OF KENNETH REXROTH, THE SLIPPERS OF CAROL TINKER Santa Barbara

STREET ARTIST New York City

EIGHT BUDDHAS Kamakura, Japan

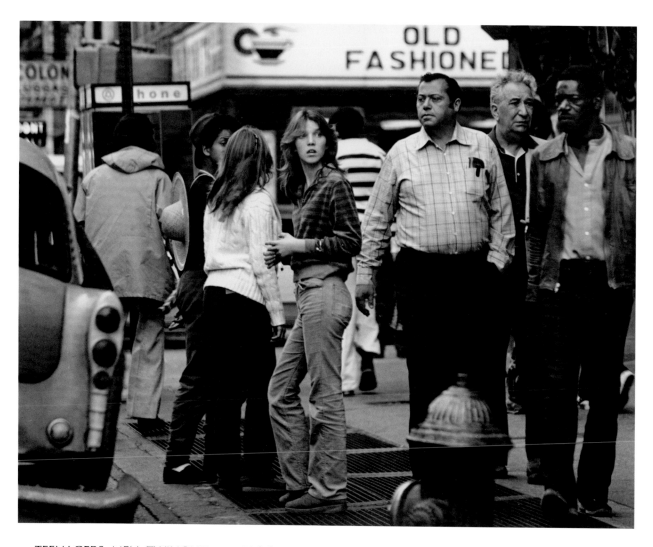

TEENAGERS, MEN, TWILIGHT Eighth Avenue, New York City

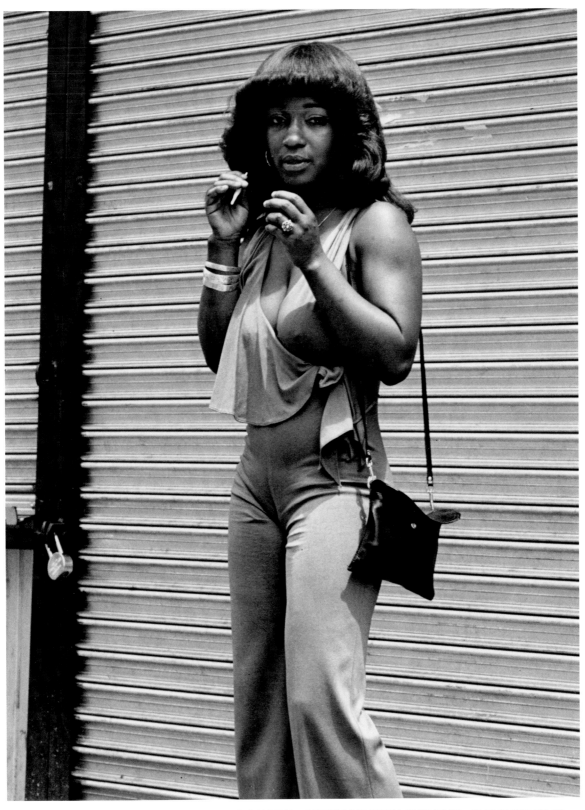

WE HAD A BRIEF ONE-SIDED CONVERSATION. *MOTHAFUCKA!* SHE SAID. SHE THOUGHT
I WAS A COP OR A NARC. Eighth Avenue, New York City

YOUNG CARPENTER Puerto Rico

190

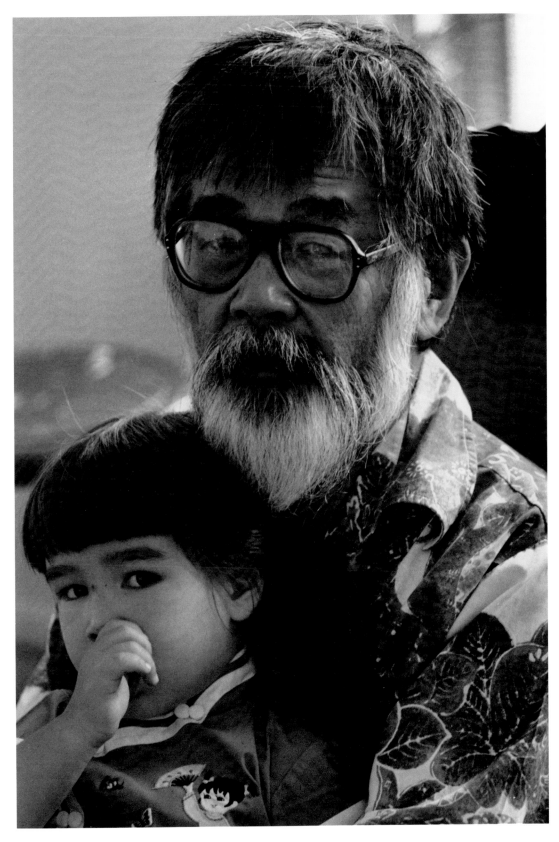

PAINTER BYRON GOTO AND ELDEST DAUGHTER, TSURU New York City

THE TREE THAT WOULDN'T DIE Santa Monica

After the great storm the city chainsawed away all the wind-broken limbs and most of the splintered trunk. In four years the tree grew back new limbs and a great green canopy.

STUMP ART California Highway

SELF-PORTRAIT ON MY WAY TO SURGERY Santa Rosa, California
Small camera held in extended right hand.

UNDER THE KNIFE OF PETER SHAPIRO, MD Santa Rosa, California
Small camera held in extended left hand. Diagnosis, colon cancer. The high-tech
surgery of Shapiro, the compassionate chemotherapy of Julius Jaffe, MD, their
loving nurses (and my own resolve) have extended my life three years, so far . . .

THE WEDDING GOWN OF ELENA S. CARAZA, DAWN Xalapa, Mexico

THE WEDDING OF VALERIE AND DUKE WAHLQUIST Riverside, California

MOTHER AND CHILDREN, BEACH Northern California

THE VANISHING RACE

I left US 70 on a hunch and drove down an unmarked Utah dirt road. It meandered into a narrow canyon between sheer rock faces. What a place for an ambush! Not the US cavalry nor my GMC van could survive the arrows and rock slides of a war party on those cliffs.

Suddenly ice ran my spine. I was surrounded by warriors in war paint! Chiefs in horned head-dress! Medicine-men casting power signs! But they came in peace, with their children, women and animals. They manifested in lifesize paintings the color of dried blood.

The white enemy had met them here before. These spirit images were pockmarked with bullet holes. The white man had signed his name to the Indian work. Added his own graffiti and signed it. He'd kidnapped one animal or child, chiseling a small neat square out of the rock (far left of photo). Good old Farley'd been here, and BW, LW, AW, and Ruth, Keith, Gale and Lee. G. H. had signed three times, in a handwriting that looked 19th century.

It all seemed a desecration of holy images. Yet the vandalism might be seen as tribute. The white visitors must have felt the power of these ancient people, their heavy presence in this lost canyon.

It was as if the white wanderers needed to add their names to history. Before they too vanished. ▲

200

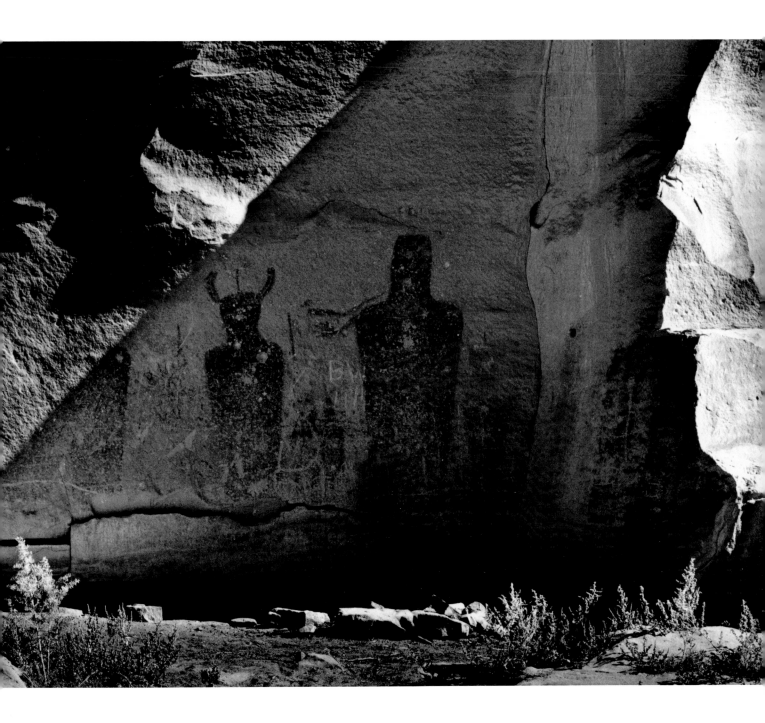

Queen of Angels Hospital, Los Angeles

VISITOR

Welcome, little one.

Are you boy or girl? Who's your old man?
Where's your mother?

You're looking out pretty sharp and col-
lected for ten hours old. Some people
would say that's because you've been here
before. Old Soul. That's a comforting
idea, wish I could believe it.

One thing *is* likely. You couldn't be here if
there weren't an unbroken chain of some
kind of life behind you, going back maybe
two billion years. That's an awesome
lineage.

Where were you before that? Are you star
dust? Are you spirit?

We hope they're feeding you a breast not a
bottle.

Hey, do you have any idea of the roller-
coaster ride you're headed for now? Hold
on to your blanket. The 21st century has to
be weird, dangerous—and full of wonder.

All our love to you.

G-o-o-o-d luck! ▲▼

INDEX of Personages

THE LYF SO SHORT, THE
CRAFT SO LONG TO LERNE,
TH' ASSAY SO HARD, SO
SHARP THE CONQUERYNGE,
THE DREDEFUL JOYE ... AL
THIS MENE I BY LOVE ...

Geoffrey Chaucer

**This book was designed by
Lou Stoumen and Renee Robinson at
Sebastopol, California, with the much
appreciated assistance of Marcus
Badgley, Marissa Roth, Sandria Miller,
Barbara Dorsey and Morrie Camhi.
Research by Mariette Risley.**

**Presswork was accomplished by
Barry Singer, Singer Printing Inc. at
Petaluma, Calif.**

Lehigh University, Museum of
Modern Art San Francisco, J.
Paul Getty Museum, National
Gallery of Canada, National
Museum of Modern Art Kyoto,
and UCLA Film Archives.

A lifelong pacifist and civil-
libertarian, Stoumen nevertheless
volunteered for service overseas
during World War Two, serving as
combat correspondent-photogra-
pher for the U.S. Army magazine
YANK in India, Burma and
China. Highest rank Tech/SGT. In
his 1978 book *Can't Argue with
Sunrise* Stoumen wrote he felt he
was *God's spy among the soldiers.*